WILDER MANN

CHARLES FRÉGER

WILDER MANN

THE IMAGE OF THE SAVAGE

To the white whale

CONTENTS

WILD AT HEART

Robert McLiam Wilson

The modern world is becoming a kind of poison. A data-stream, a global network. I feel all networked and isolated, at the same time disconnected and too connected. I feel like I am living in a factory, actual and virtual – alimentary, sanitary, moral and philosophical. There's too much to read and too much of it is stupid and deceitful. There is too much to watch and too much is dire and repellent. I no longer know if I am the consumer or the consumed. I feel as though someone has industrialised my mind.

And we are becoming strange to each other. We are surrounded by, and part of, the first-world torpor of a networked billion slumped over their computers in a festival of onanistic stasis, a riot of inertia. We are stuck and the mud is rising and thickening, our muscles wasting and shrinking. It's already hard to move and soon we will struggle to breathe. But perhaps by then, they will have industrialised or virtualised respiration. By then they will have automated our very breath.

And what have we thus sacrificed ourselves for? The depthless grand guignole of mass media idiocracy, the primary-coloured infantilism of 21st century democratic politics, the pixellated armageddon of computer games or the unstoppable Dunciad of the Internet where the mistake is king and as everything gets easier, everything gets dumber. The mores, motives and memorialising of the uncorrected generation.

And we gave up religion for *this*?

We are losing ourselves and losing each other. And we seem to gain nothing in its place.

But there is resistance. Muted but growing. Individual and collective. None of us is happy with this. We remain essentially who we have always been and in the midst of our supine acceptance of this climate change of disconnected superficiality our unease burgeons, a traffic jam in our clogged hearts and our emptying heads.

It is increasingly clear that some form of ghostly, almost undetectable tide has turned. We twist and turn in our high chairs, turning our faces away from the Reaganite data-spoon like mutinous toddlers. For, wonderfully enough, though our bloating and sickening bodies can endlessly absorb and process the sugared toxins of 21st century free-market sub-sustenance, our minds just can't keep munching on all those endless biscuits, cakes and sodas without a spectacular emetic reaction.

Hey, good for us!

Plugged in, neurotically wi-fied and G3d as we are, we yearn to re-establish contact with the actual, the primal, the *old*. We dream of something real, something unmitigated by the filter of profit-making portals and franchises. We want the as-was, the erstwhile. We languish for the non-mechanical and the pre- or post-industrial. We are pilgrims seeking the past, the genuine, the individual.

The young appear to be taking their political models from movements or developments that are jaw-droppingly ancient. The Levellers or the Luddites in Britain, Jacobin radicalism in France and War of Independence rebels in America. The anti-globalist,

anti-capitalist or environmental postures of the young could be seen as having an increasingly 18th or even 17th century flavour. There is the great hope that despite the communication industry's torrent of stupidity and mendacity that we will remain as gloriously heterogeneous and spikily iconoclastic as before. I notice that people much younger than me have a much less manichean set of cultural assumptions or inheritances than my own. Their information-sets are piecemeal, fragmentary. They like this kind of music and this other kind of film and an entirely unpredictable kind of politics and then another subset of activisms or pursuits, unpredictable sometimes, even contradictory. This younger culture is much harder to define, harder to control and very much harder to sell.

Ironically, it may well be the Internet that best demonstrates this. Indeed, the foolish, shallow pornographic daydream that is the Web may be the great arena for the rehearsal and diffusion of these communal individualisms, these new archaisms. This is how people under forty inform and fortify their principles, their culture. This is how they amass and disseminate. How they share and teach and learn.

Of course, you can wade through a million websites about Paris Hilton but you can also find an almost equal number of places discussing, analysing or promoting extraordinarily old-fashioned or backwards-leaning pursuits: pilgrimage, Druidism, shamanism, nomadism, transhumance, land-living. Jesus, there is an entirely sincere YouTube video showing you how to make an amphora (for daily use!). Longbow archery is suddenly beginning to outdistance the actual sport of archery in popularity. And you have to make your own bows. And it takes *months*. This hypermodern format is often devoted to instruction in Bronze Age beliefs and crafts.

Everywhere there are strands and networks of revivalisms and reviewings. Ancient skills and lores, dilettante survivalism and how-to historicism. And it is not just the internet and its sellotape and pipe-cleaner reconstructions of pre-industrial arts, crafts and beliefs. One of the more gob-stopping surprises of the last decade has been the cinematic and televisual rebirth of fantasy as a genre (and what is that genre if not a rehashing of old primal archetypes or half-remembered pre-Christian myths?). Tolkien reconquered the world with his ersatz beastmen, treemen and half-men. Suddenly it was all dragons and sorcery. Christian Bale is ducking the fire-breathers, Jeremy Irons is riding them and Brad Pitt is learning to swordfight. People are watching this stuff in their millions and feeling their hearts beat as fast as any 12th century peasant listening to a fireside tale of demons, witches and wild, dark things.

Welcome or unwelcome, explicable or inexplicable, this prompt or pattern is undeniably real. Our dissatisfaction with our mental or spiritual diet is expressing itself despite us. It leaps out. Our imaginations are choking and constipated by the confections of *Call of Duty 4* and *Transformers 5*. Our souls are crying out for the roughage of the primal.

And in this search and in this new presence, the figure of the wild man, l'homme sauvage, the wildermann runs like a dark and flickering thread. This emblem of altereity, of the literal outsider has been a part of our consciousness since we first formed nomad bands or settled into agricultural communities. Perhaps even earlier. It is an almost founding myth, definitive. To have an *us* we need a *not* us. It is an integral part of our understanding of ourselves. We need to define who we are by first defining who we are not. We are Tame Man because we are not Wild Man. We know what we trust because we know what we fear. We feel included because of what is excluded.

The wild man image has faded and returned throughout the ages. It has warped and changed, grown tall and small, hairy or bald, a good or an ill. Classical mythifying and didacticism meant the figure could be actual or figurative, outside us or a part of us. In the Middle Ages, Christianity peppered it with its own darkness and prissy squeamishness, at once internalised, dramatised. Yet even then, the wild man formed the dark backing, the reverse reflection of that most holy of figures, the hermit, sharing the space outside the group, sharing the space in the minds of the group. An automatic gainsay, a contradiction.

Jonathan Swift allowed this atavistic figure to run through his work and vision like a dark, productive seam. Rousseau played with it in typically dilettante but witty fashion. The conflation of the wild man and bogie man was never far away and the invention of the novel meant that this alloy sharply solidified. Mary Shelley gave it some thought, some sentiment, and stirringly Protestant moralism and a thousand Frankensteins were born.

The figure never fades but changes tone and character often and dramatically. Now a black emblem of atavism and fear, now a faintly comic grotesque, now a totem of sexual and behavioural licence. A harbinger of spring or winter, a strawman to be killed or feted. The modern age has thrown up its wild men substitutes. It's scapegoats and bogles. The spectacularly neurotic American over-reaction to Charles Manson is explicable in these terms. What else was he, this figure at once pathetic and disturbing? The malicious Munchkin, laughably ignorant and yet capable of seducing and controlling others. His ungovernable narcissism and hollow posturing repelled and intrigued at the same time. The witless sociopath propelled to prominence by the 20th century's dumbest decade and celebrating his success in random bloodletting of stunning futility. What else was he but a kind

of wild man and bogie man rolled into one? A thing to pillory and burn in order to purge ourselves of our communal fears and private atavisms. And now, almost everywhere, we have a new one every year.

And it is in ritual and mimetism that we exorcise or celebrate our demons and our angels. Our included and excluded, our permitted and forbidden. In becoming the monster or the other, we make it part of us again, a thing to be directed or followed, a negotiable, tolerable commodity. We clip its claws or sting by mimicking them.

This totem, this imago, at once distanced and within us, is often a distillation of communal traits and faults. A personification of sins or desires, of failures or fears. It is a way to *communally* dramatise our own otherness. For though ritual and costume pertain to the many, the figure is almost always strikingly solitary. It highlights the *me* in 'us'. The primacy of ego or id finding place in the group (or losing it). Expunged or absorbed, it is formally resolved. A circus of the hidden parts of being human, the depiction of this figure rehearses hopes, fears or drives, which we only know we have when we thus share them in community.

The figures in these beautiful, disturbing images speak to our depths, to something old in us but far from forgotten. I keep seeing figures similar to ones in these pictures. They seem to persist in popping up, in the full rig, long cloak or straw breastplate, stilts or heels, animal skull or face plate, horns or antlers. In rock festivals and impromptu outdoor techno parties, in M. Night Shyamalan films, at anti-globalism protests and G8 riots. I even saw one in November 2008 in Limerick when Munster played New Zealand at rugby (where in the name of God they got antlers in Ireland truly boggles the mind) and even just this summer

I saw an Indian cricket fan so dressed, lamenting another defeat by England in London.

So this atavistic hangover, this vestigial remnant seems to be fully modern and increasingly so. The figure is being revived through modern telecommunication, a style and an idiom that has barely changed in millenia. And defanged by our celebration or immolation, we thus endlessly render social the dark, ancient material of human urge.

Hey, good for us.

PLATES

Wilder, Telfs, Austria

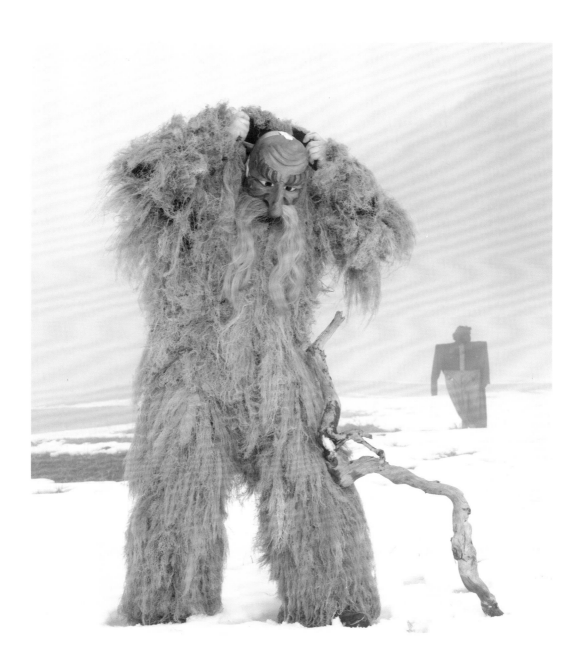

[opposite and following page] *Wilder*, Telfs, Austria

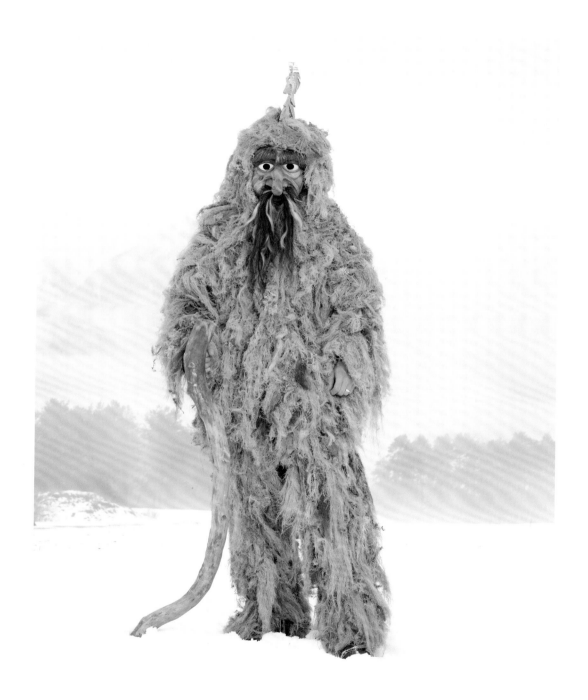

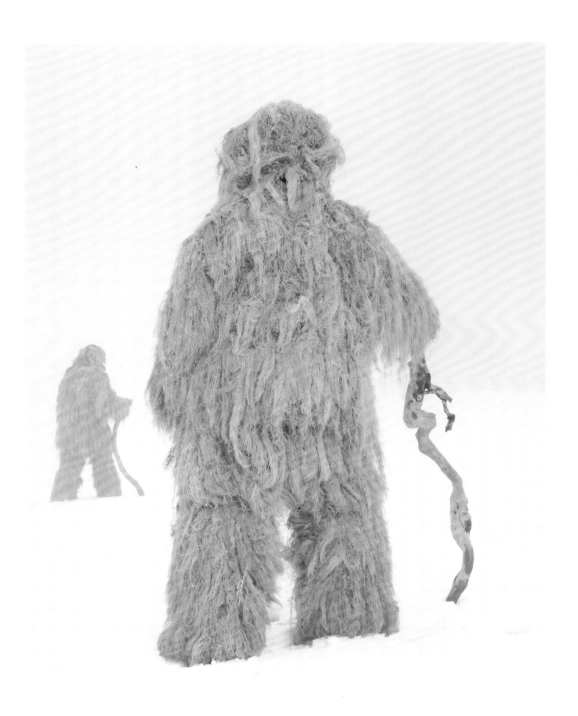

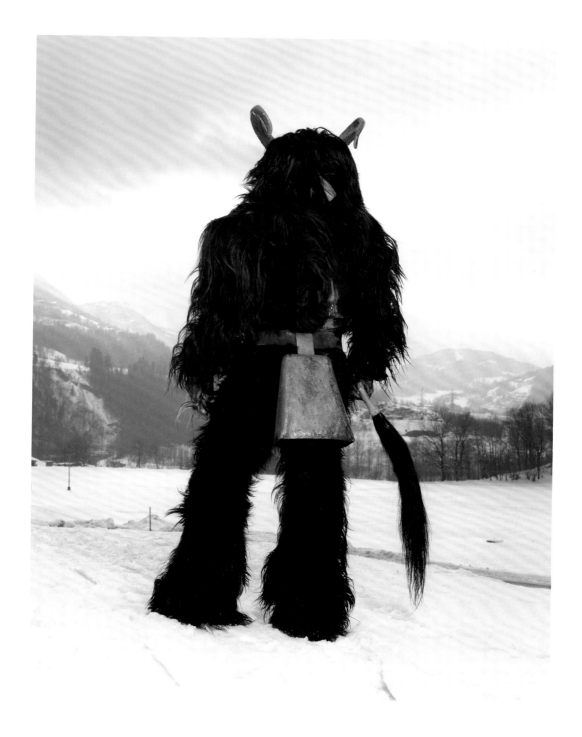

[previous page and opposite] *Perchten*, Werfen, Austria

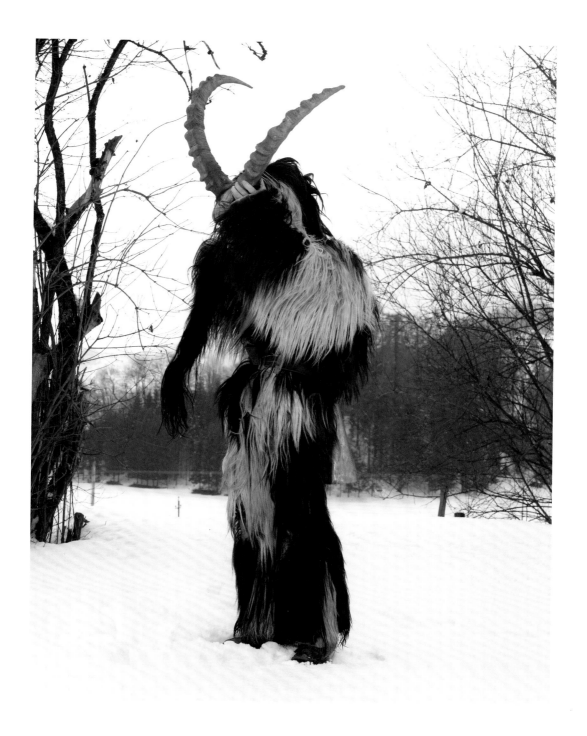

[opposite and following double page] *Perchten*, Werfen, Austria

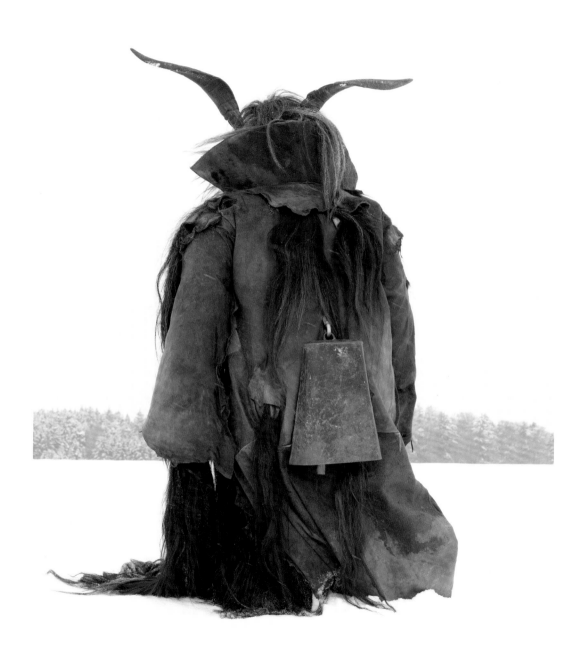

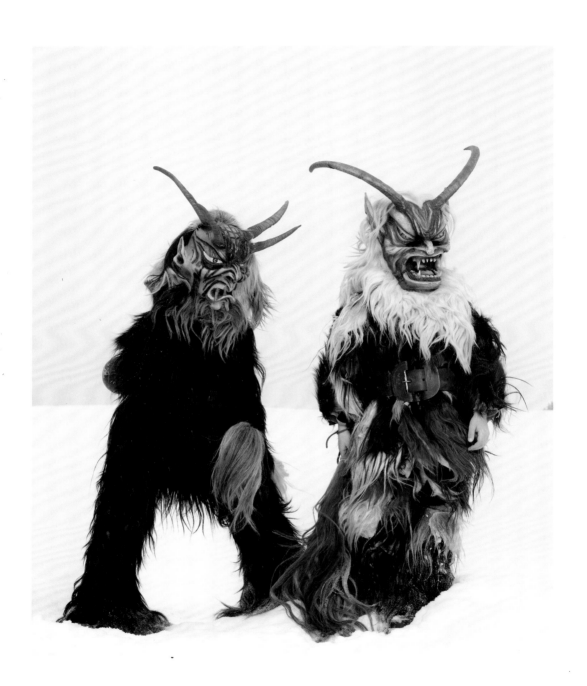

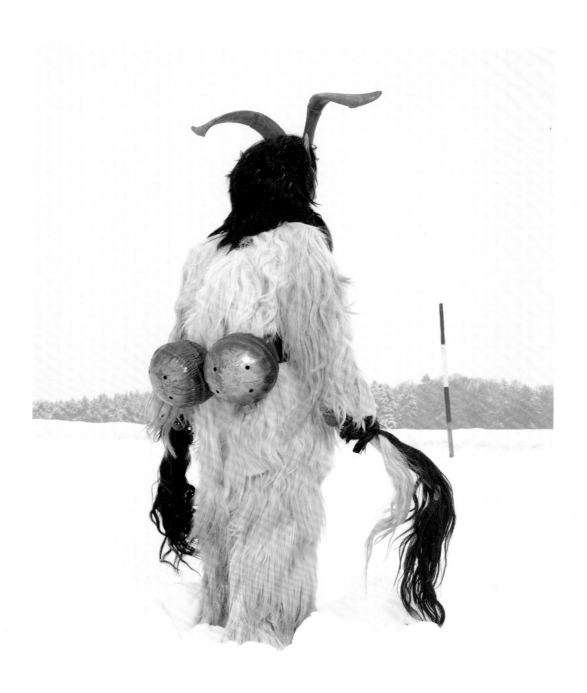

Krampus, Bad Mitterndorf, Austria

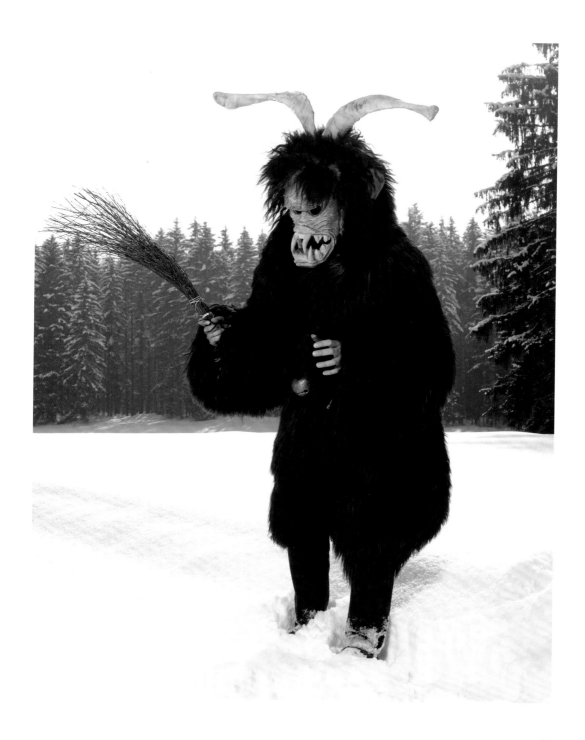

Krampus, Bad Mitterndorf, Austria

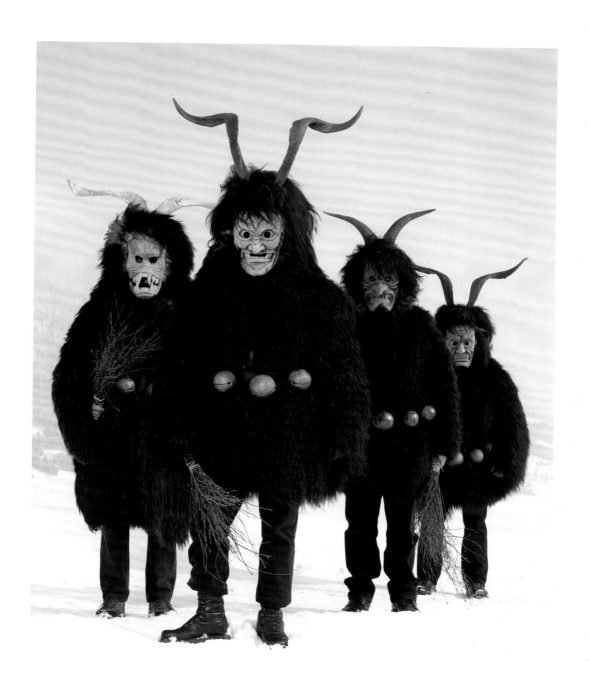

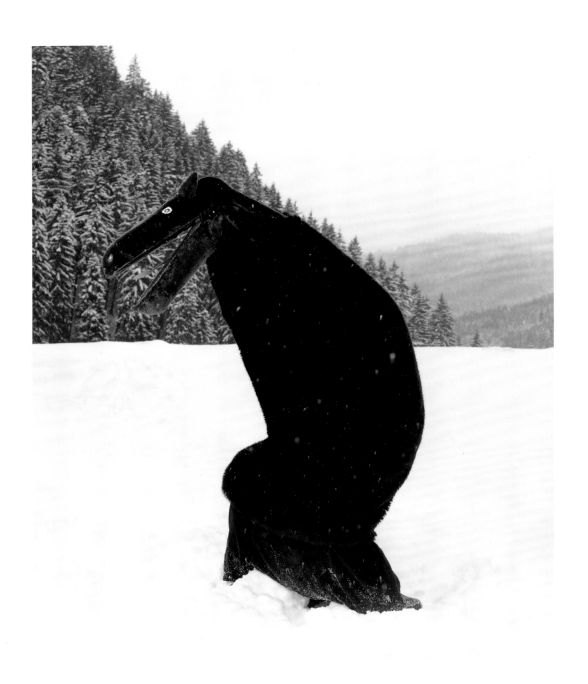

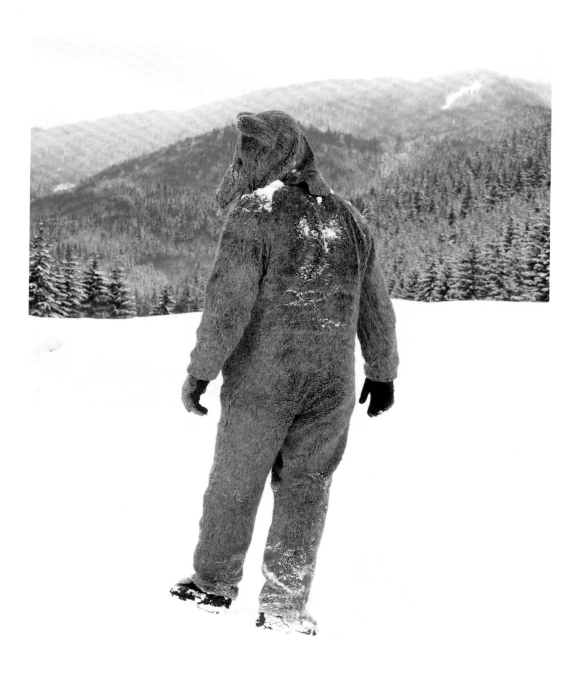

[previous double page] *Chriapa* (Goat) and *Medved* (Bear), Ružomberok, Slovakia

Smrt (Death), Třebíč, Czech Republic

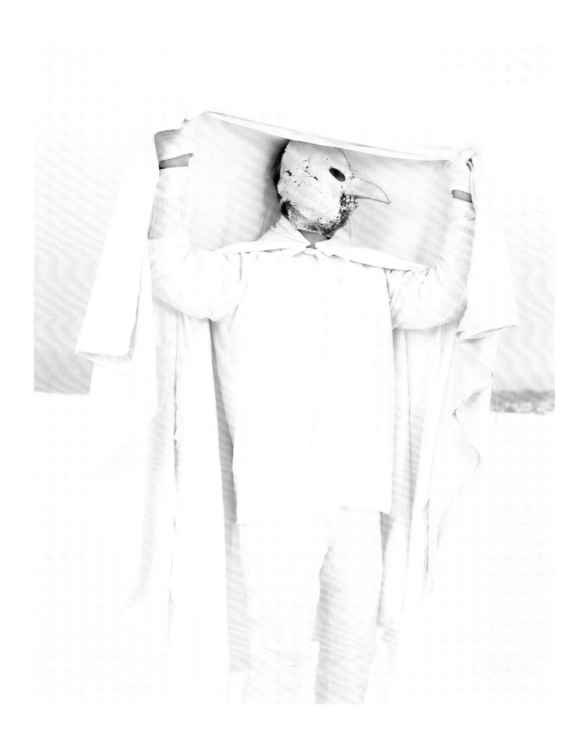

Laufr (Jumper), Třebíč, Czech Republic

[following double page and page 40] *Certi* (Devils), Třebíč, Czech Republic

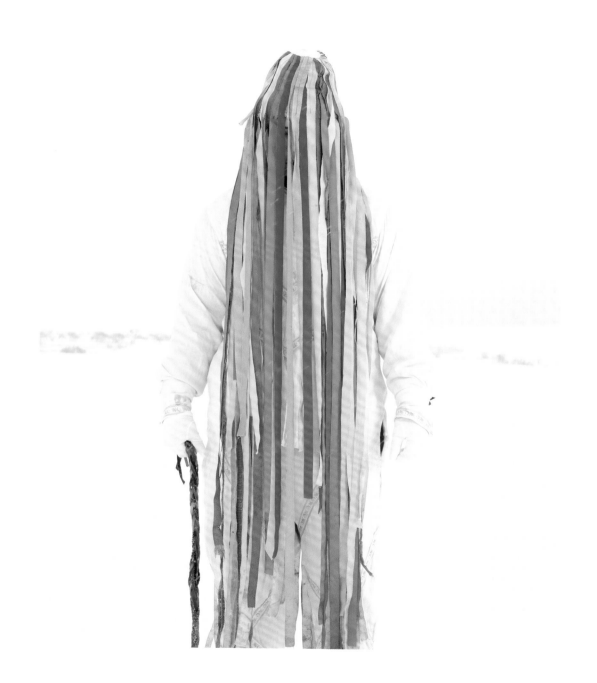

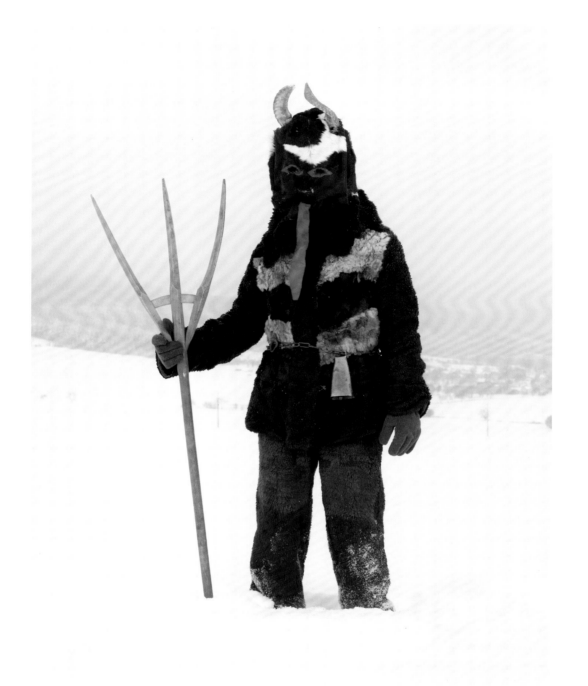

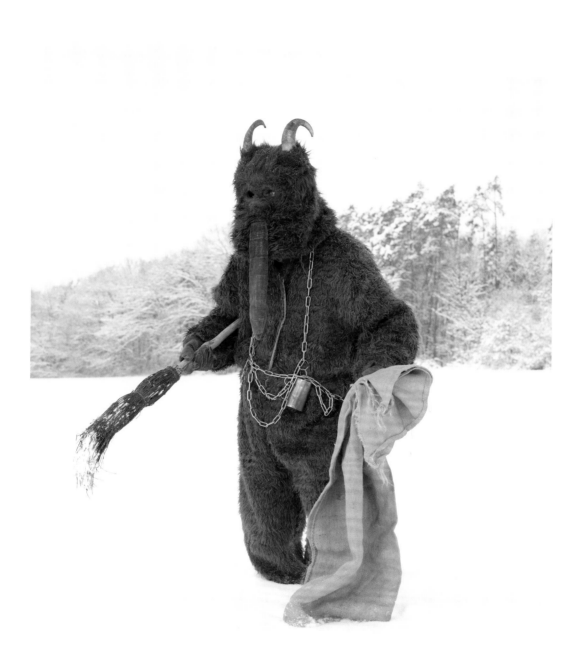

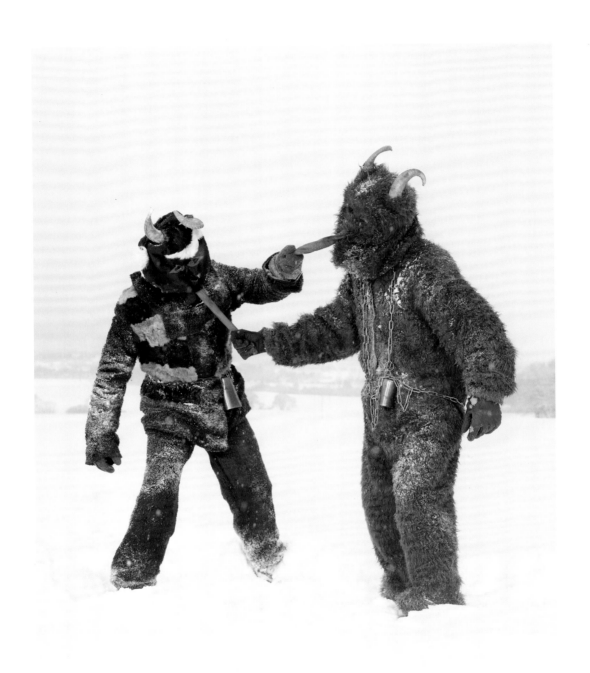

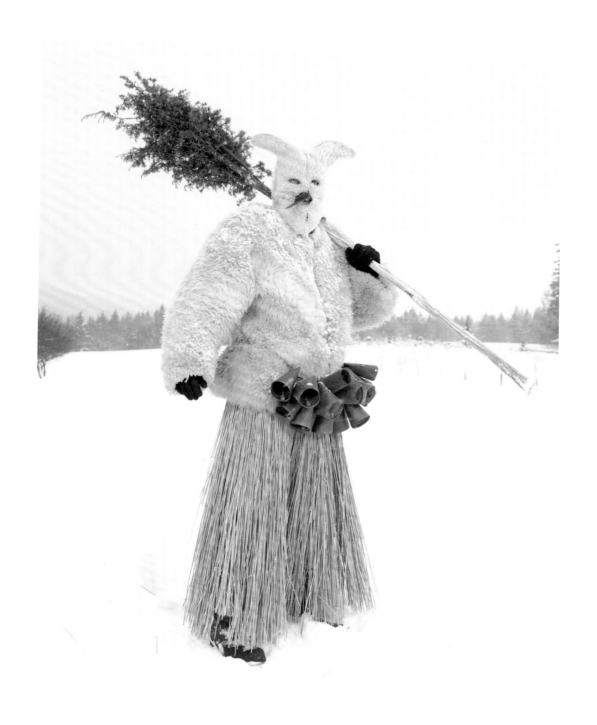

[previous page and opposite] *Certi*, Nedašov, Czech Republic

[following double page] *Macinula*, Cisiec, Poland

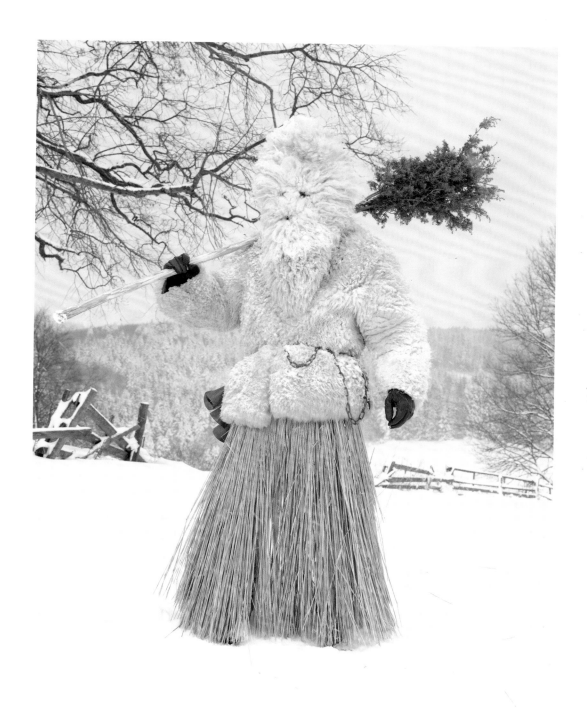

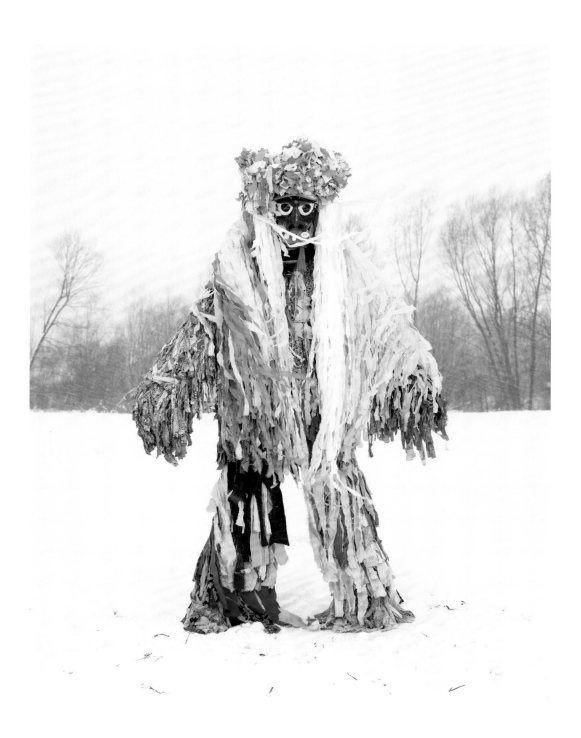

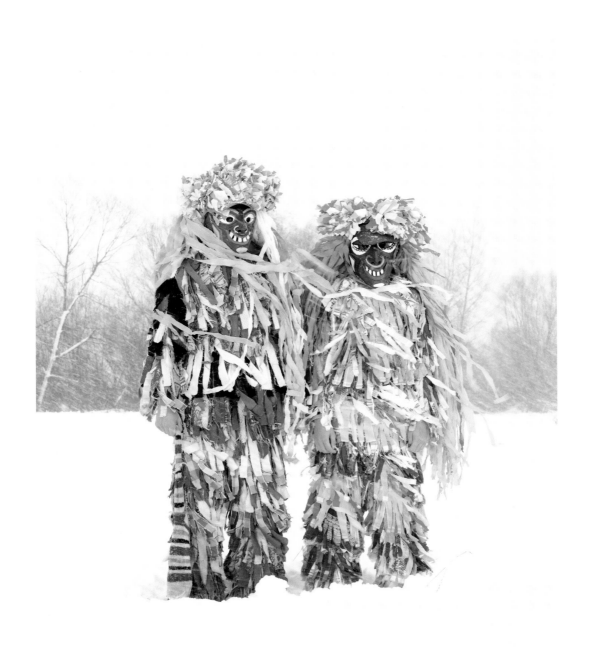

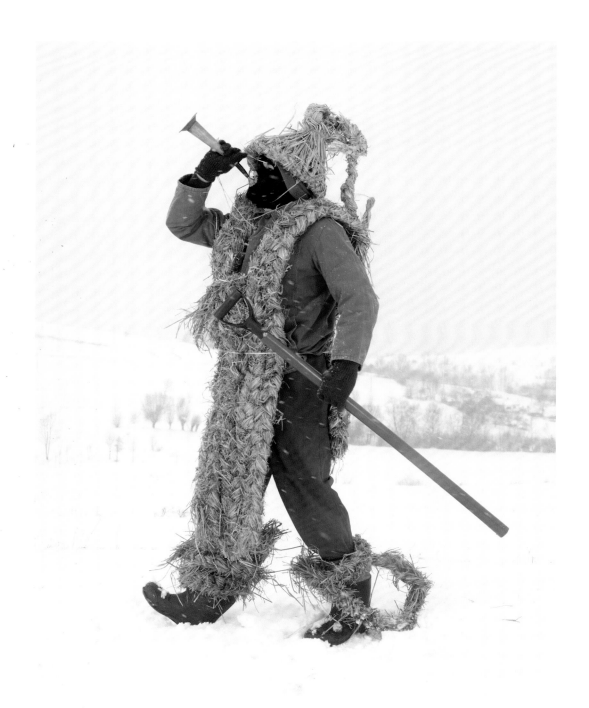

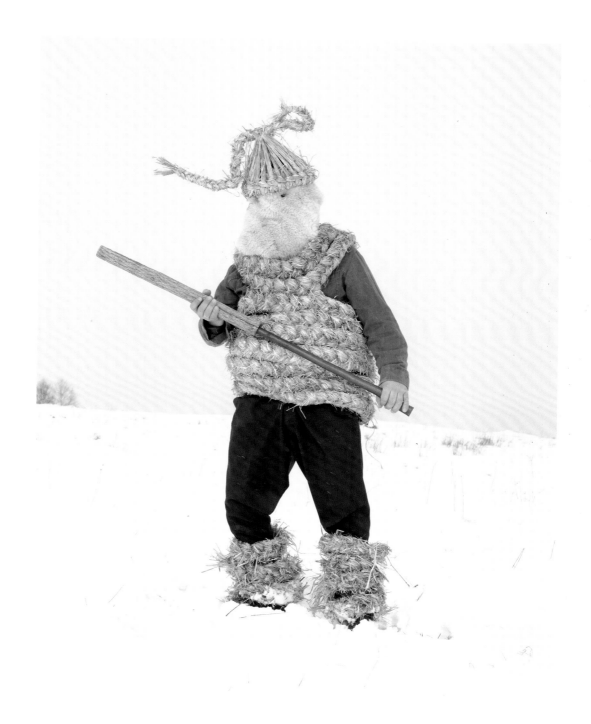

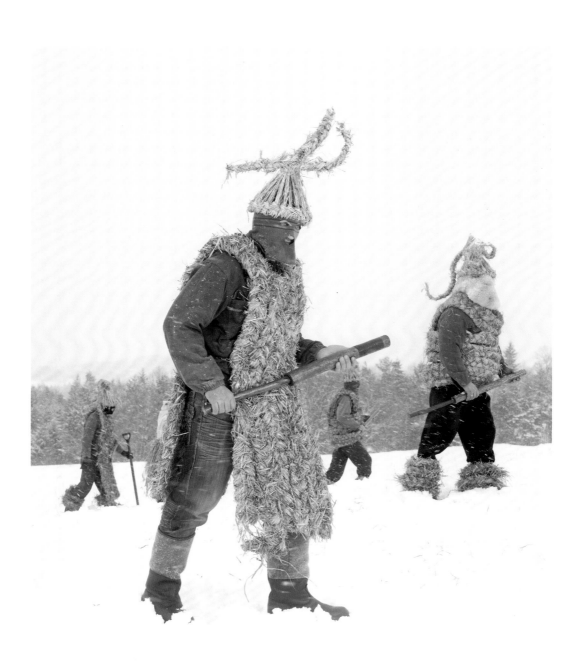

[previous double page and opposite] *Dziady Smigustne*, Dobra, Poland

Strohbär (Bear of straw), Ewattingen, Germany

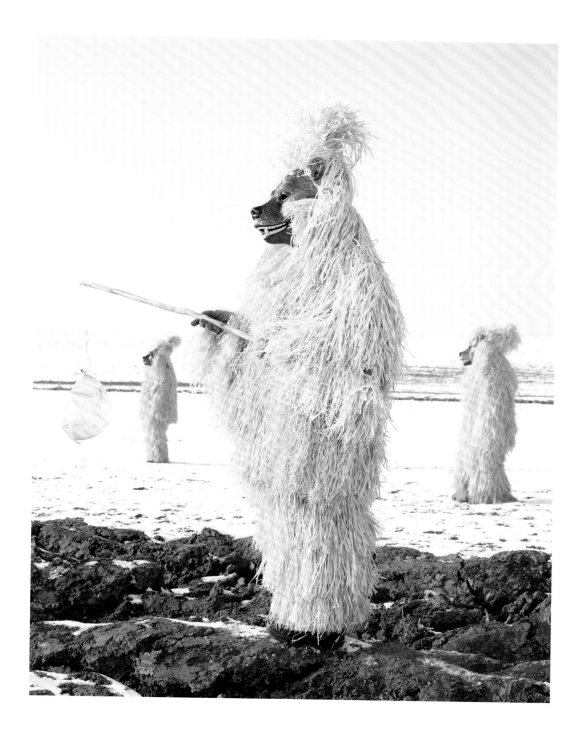

Reisigbär (Bear of twigs), Empfingen, Germany

[following double page] *Reisigbär* (Bear of twigs) and *Erbsenbär* (Bear of peas), Empfingen, Germany

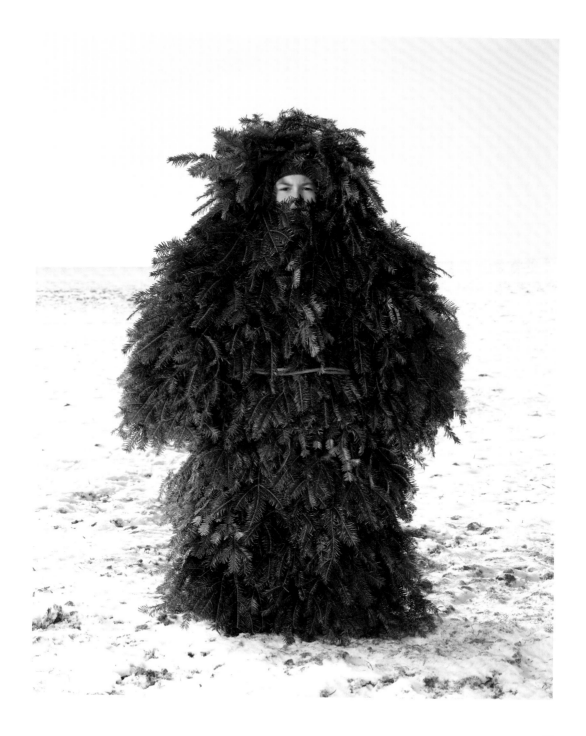

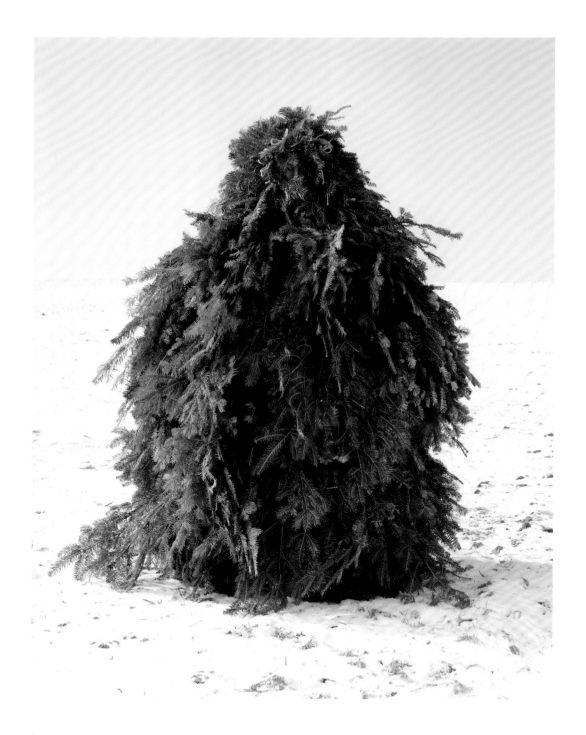

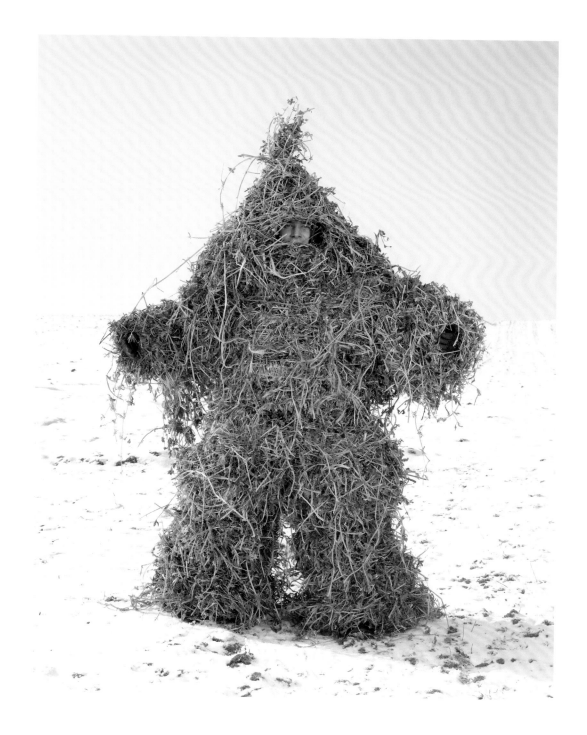

Strohmann (Straw Man), Empfingen, Germany

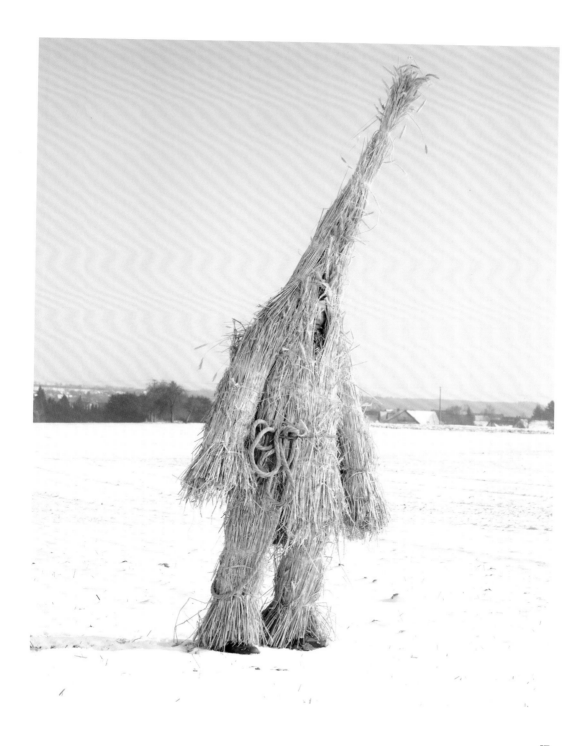

Strohmann (Straw Man), Leipferdingen, Germany

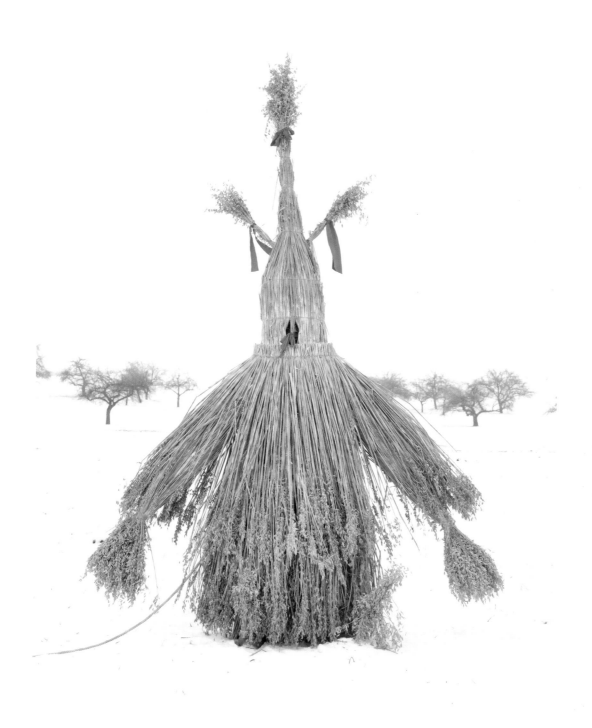

Pelzmärtle, Bad Herrenalb, Germany

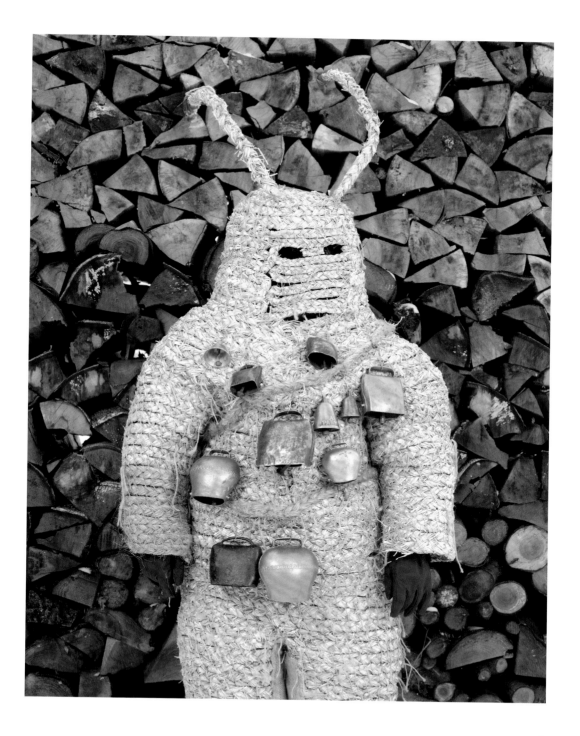

[opposite and following double page] *Tschäggättä*, Lötschental, Switzerland

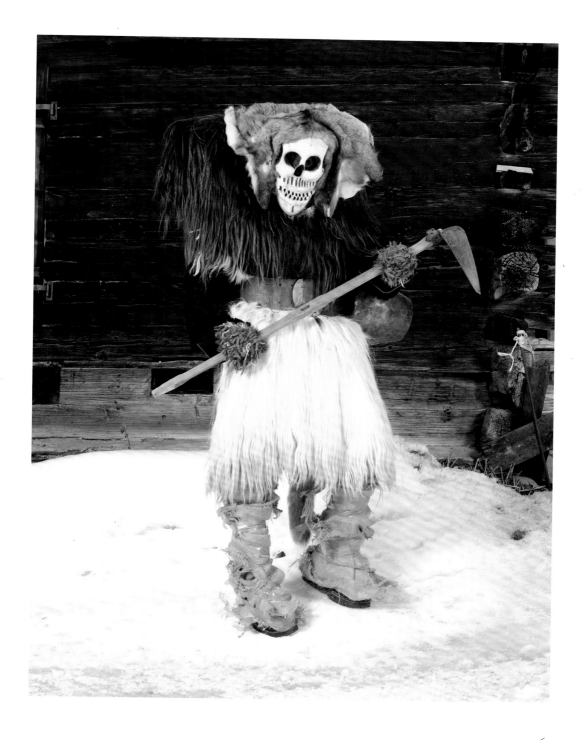

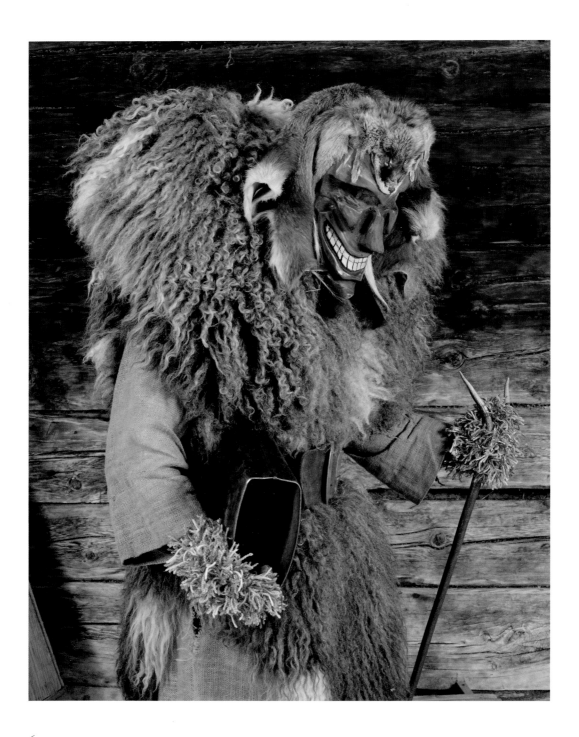

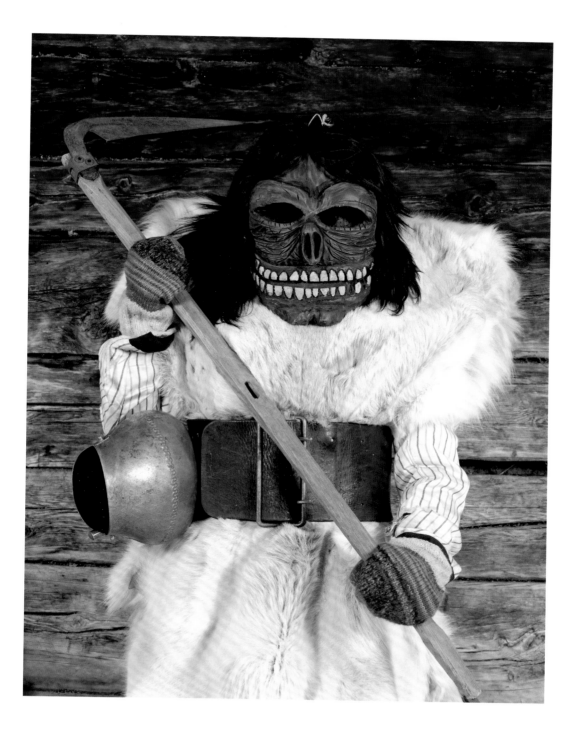

Tschäggättä, Lötschental, Switzerland

[following double page] *Peluche* and *Empaillé*, Evolène, Switzerland

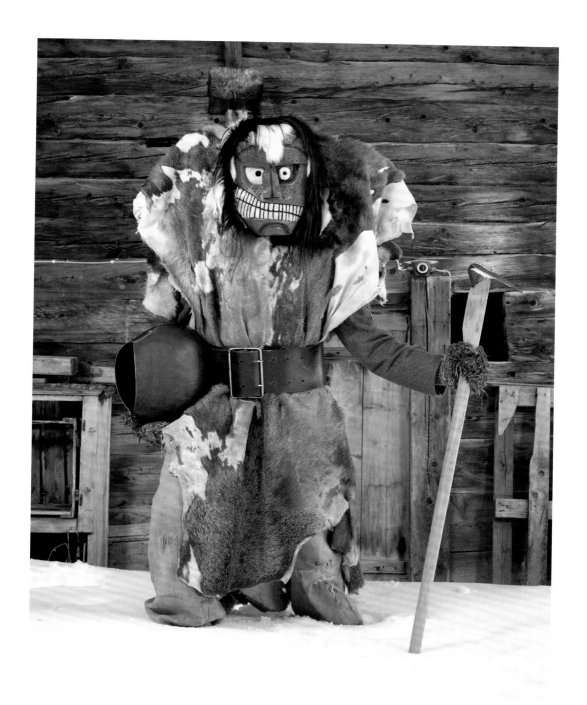

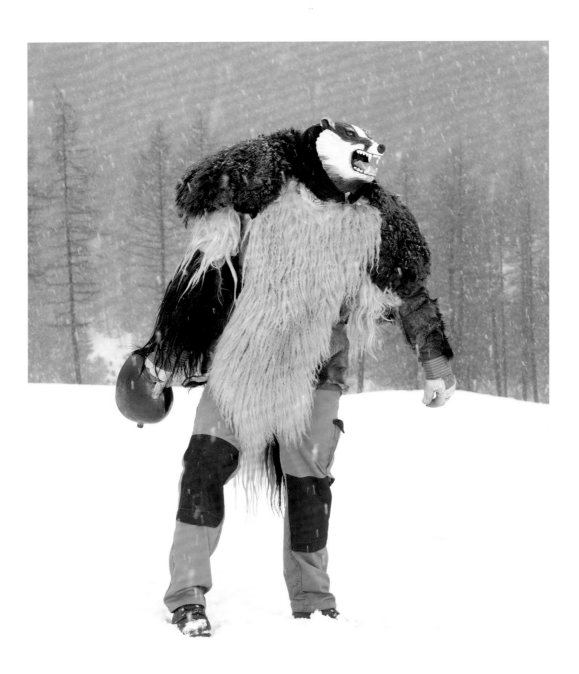

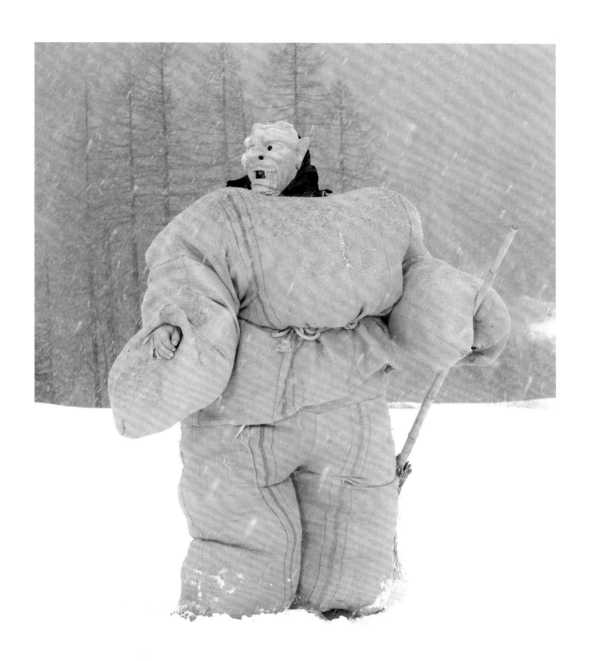

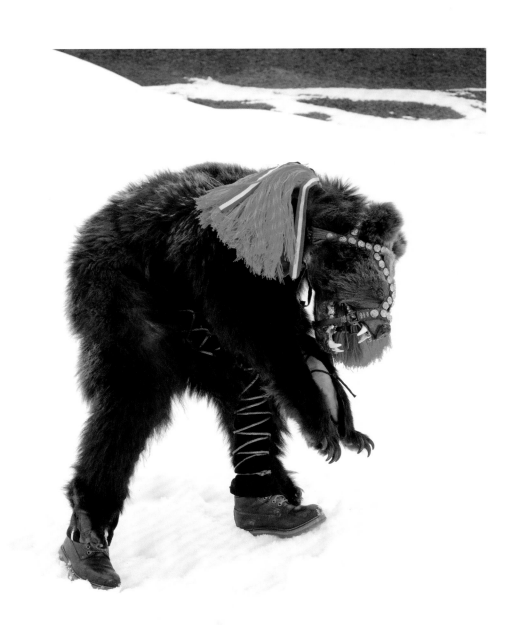

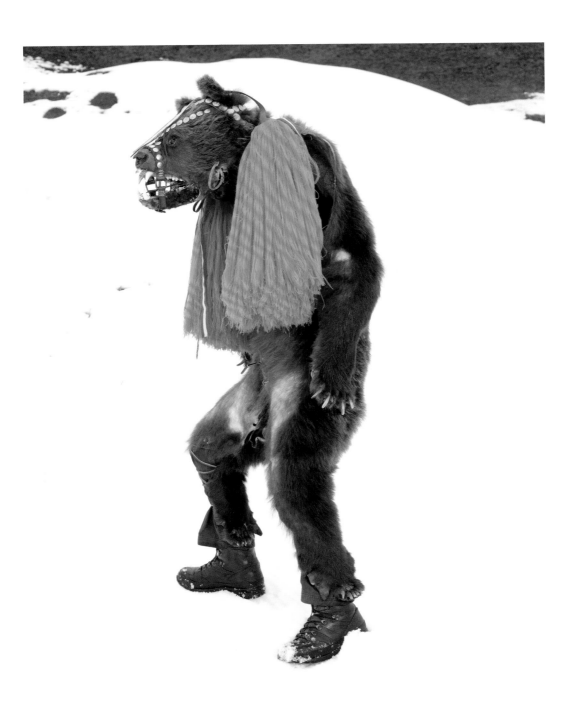

[previous double page] *Ursul* (Bear), Palanca, Romania

[opposite and following double page] *Urati* (Ugly people), Palanca, Romania

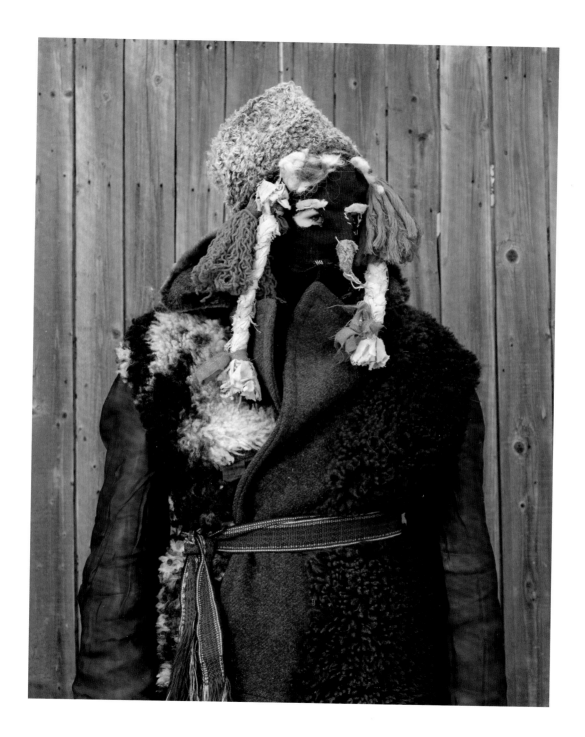

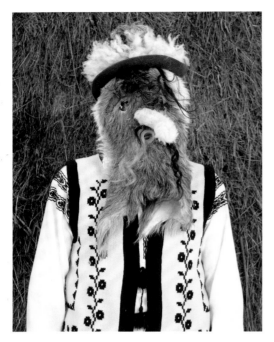
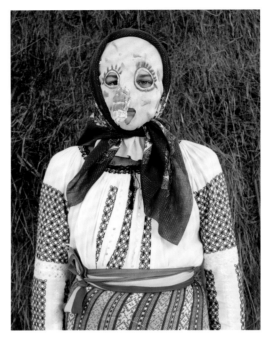
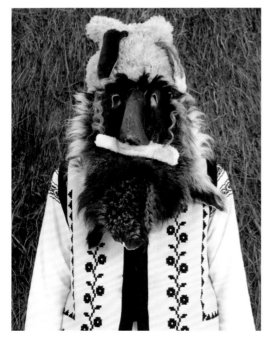
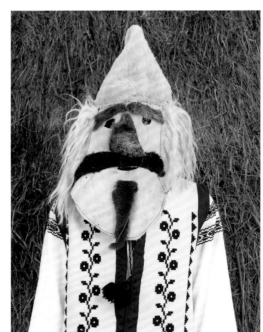

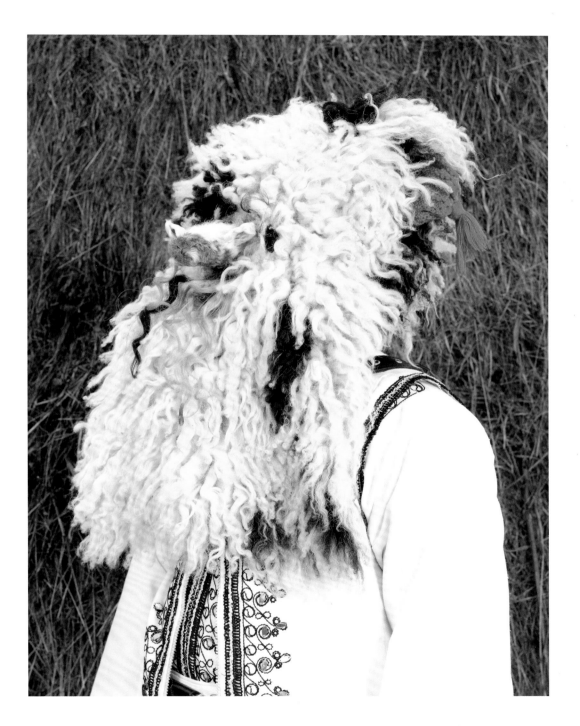

Capra (Goat), Mălini, Mănăstirea Humorului, Romania

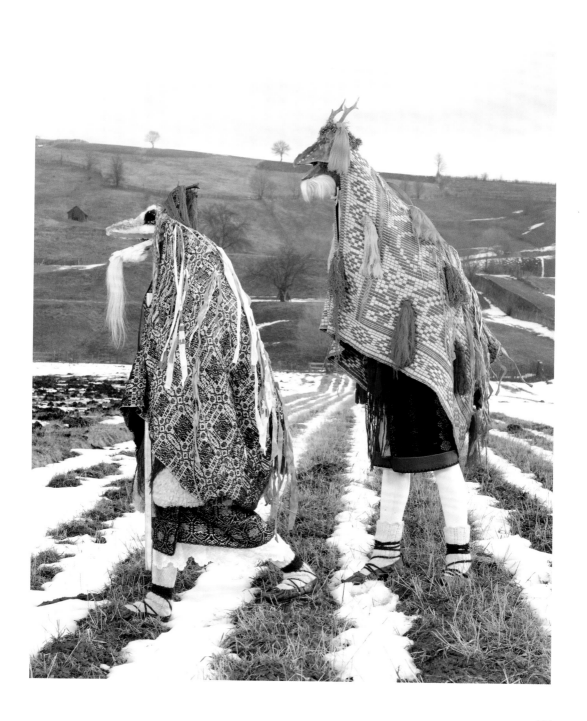

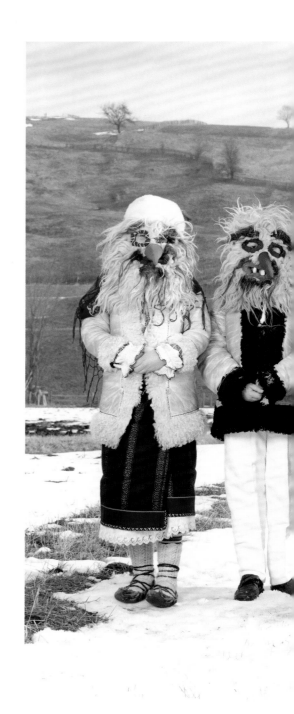

Masquerade of the Goat,
Mănăstirea Humorului, Romania

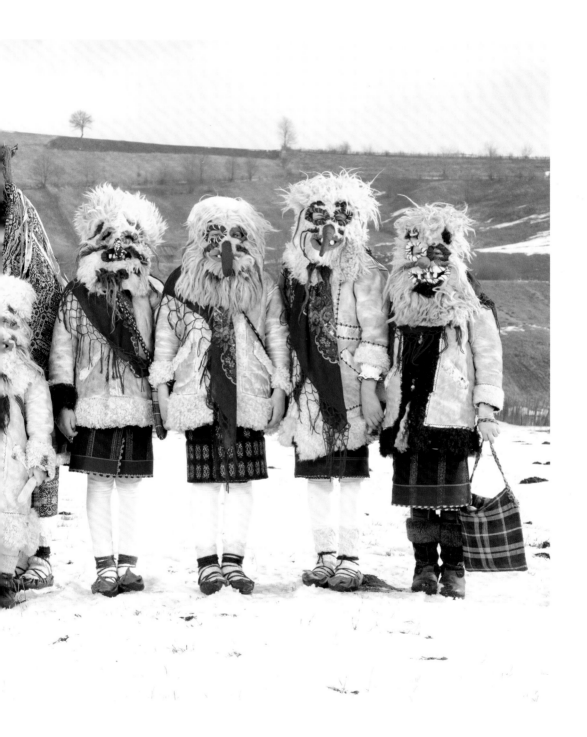

Cerbul (Stag), Corlata, Romania

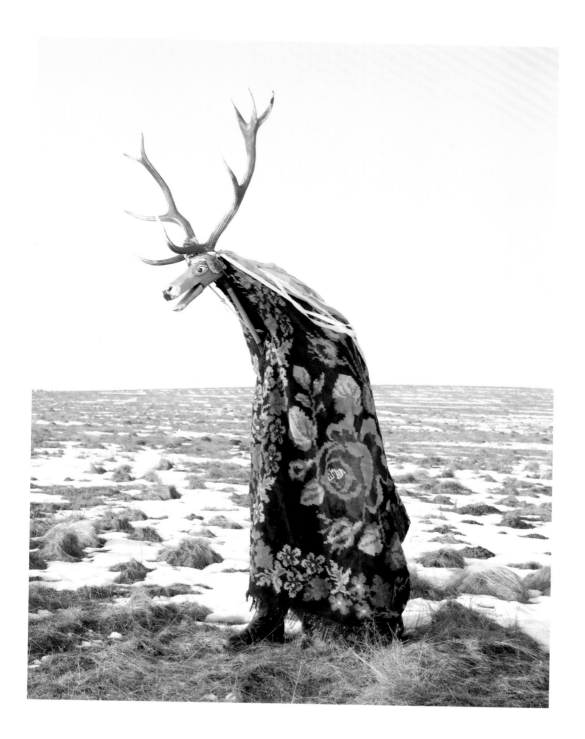

Capra (Goat), Mălini, Romania

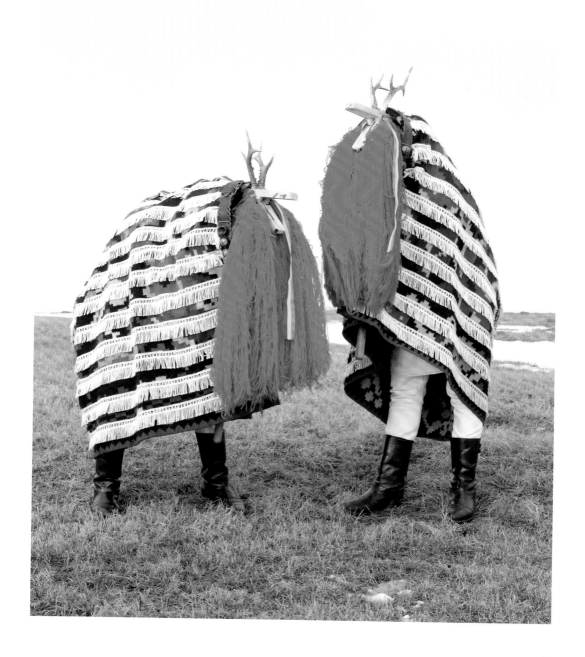

Ursul (Bear), Boroaia, Romania

[following double page] *Ursul* (Bear), Udešti, Romania

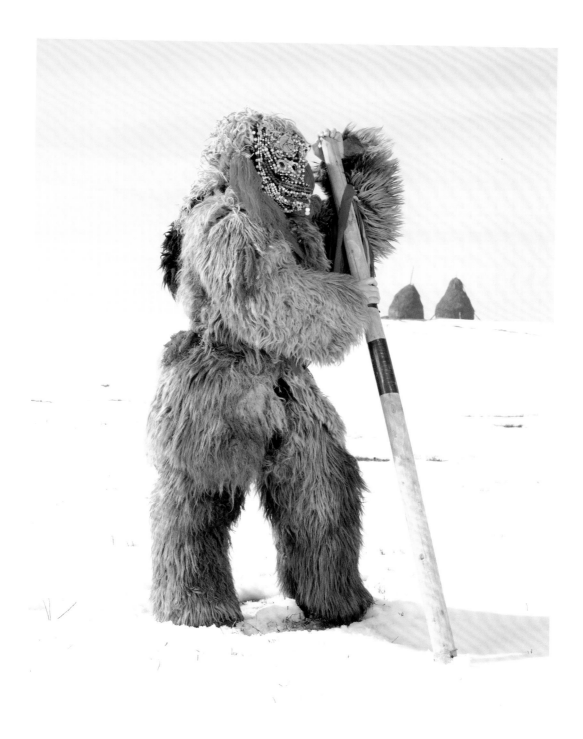

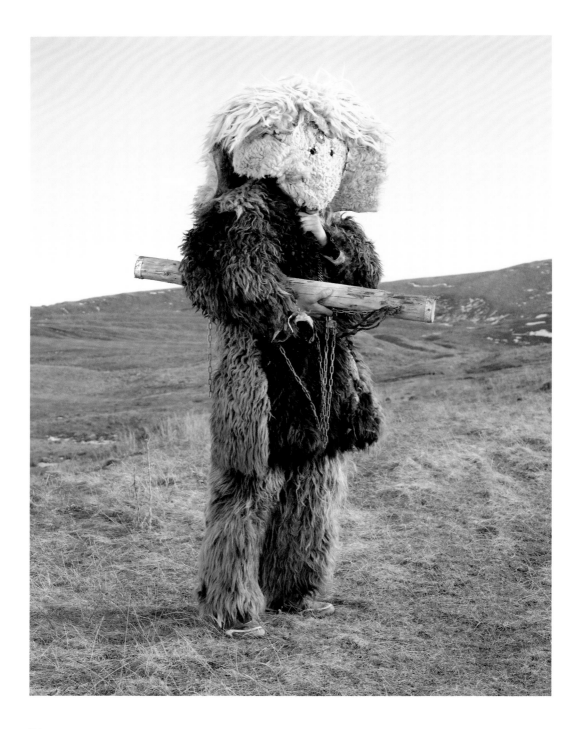

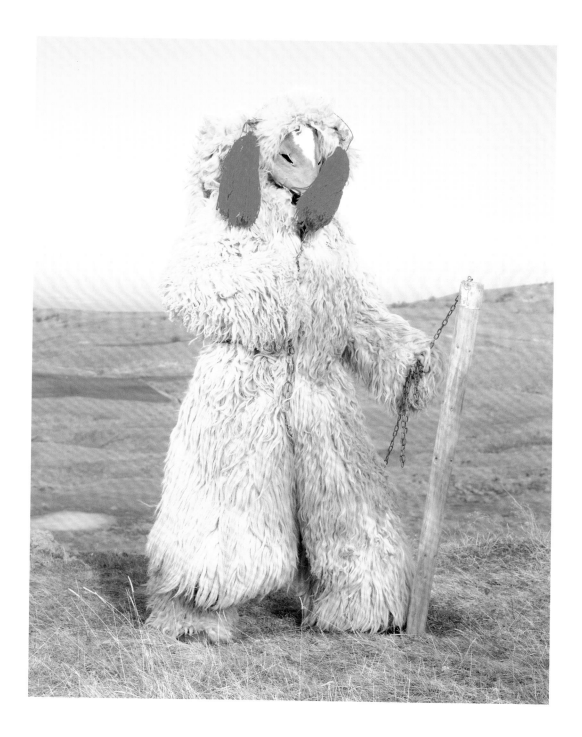

[opposite and following double page] *Nuuttipukki*, Sastamala, Finland

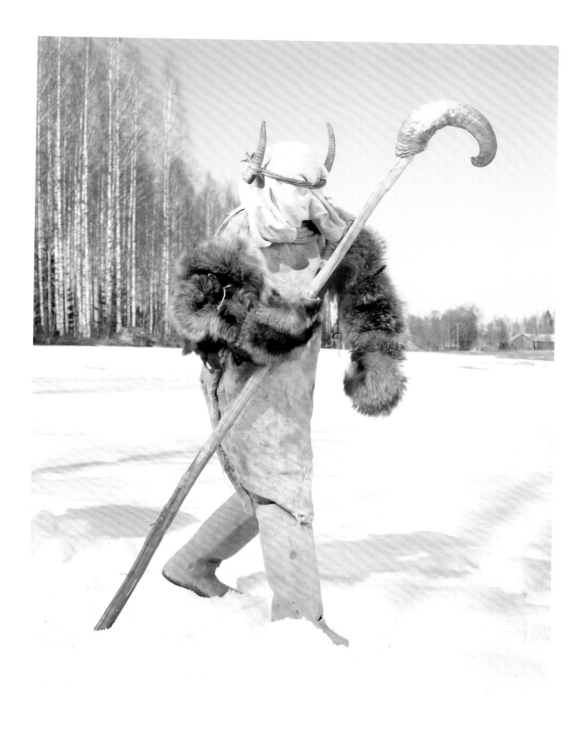

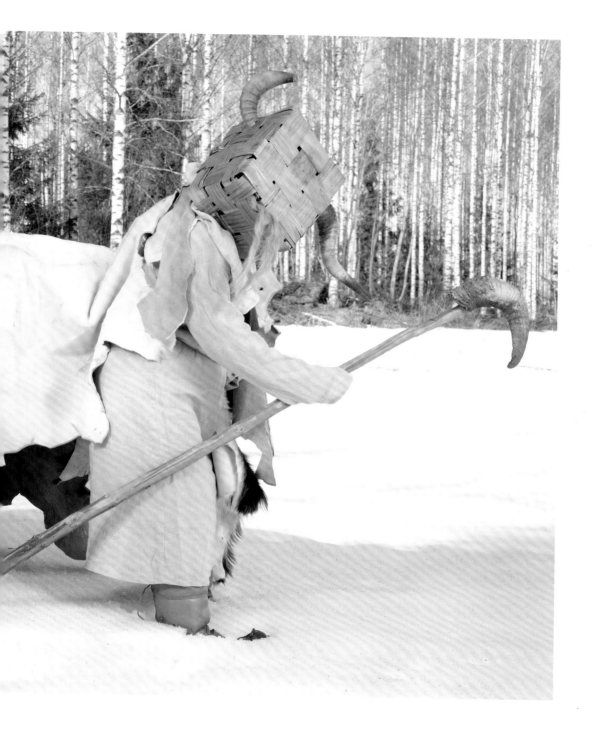

[opposite and following double page] *Nuuttipukki*, Sastamala, Finland

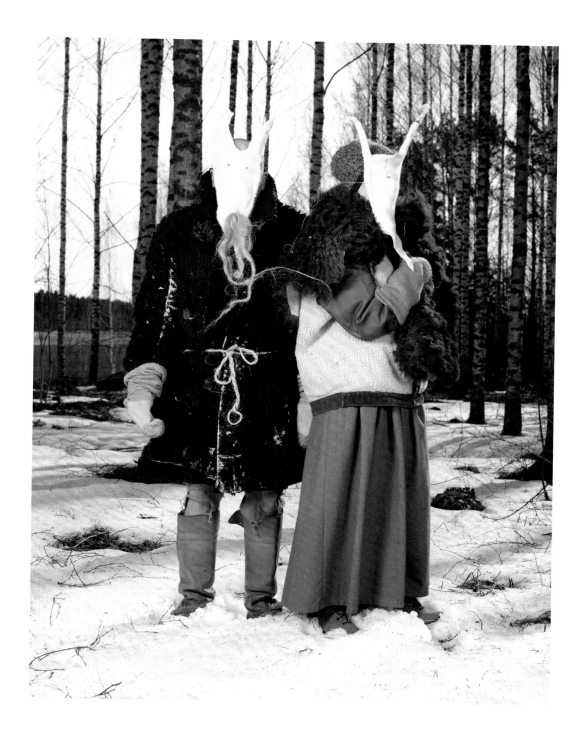

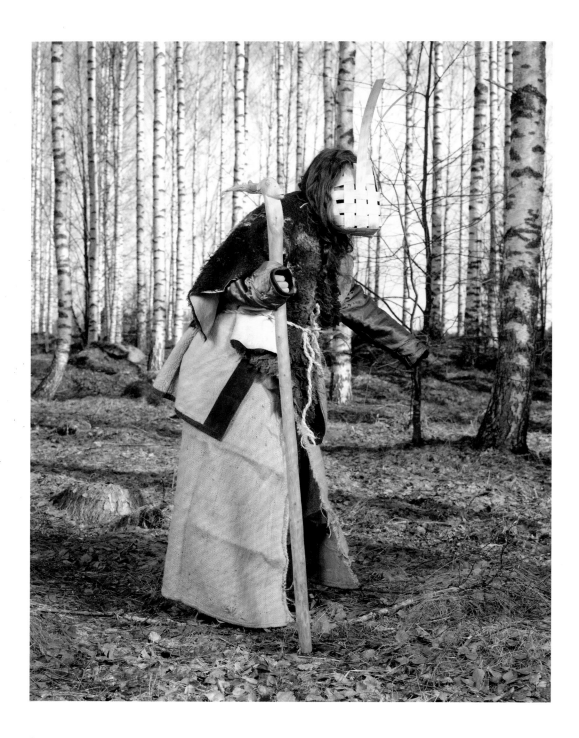

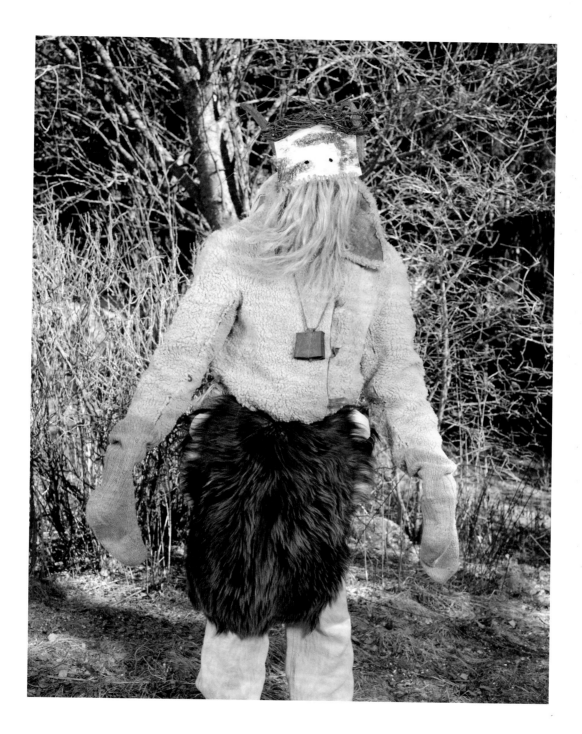

Nuuttipukki, Sastamala, Finland

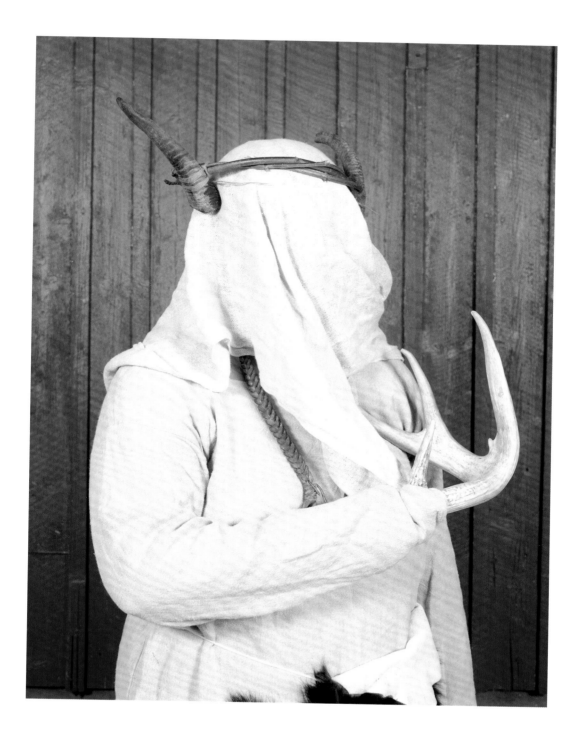

[opposite and following double page] *Sauvages*, Le Noirmont, Switzerland

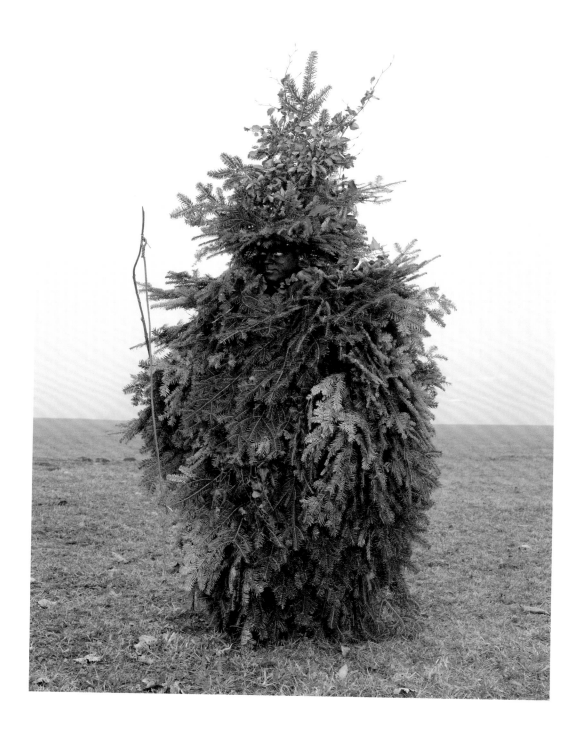

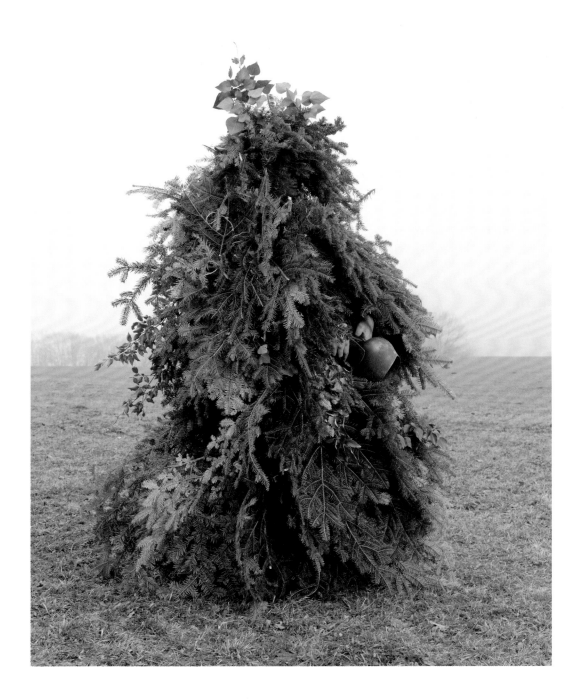

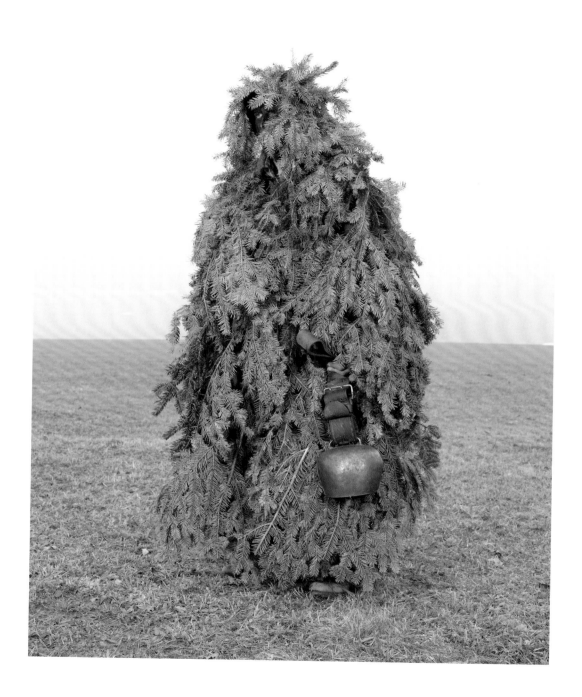

Habergeiss (Goat), Tauplitz, Austria

[following double page] *Luzifer und kleine Teufel* (Lucifer and his Devils) and *Schab*, Tauplitz, Austria

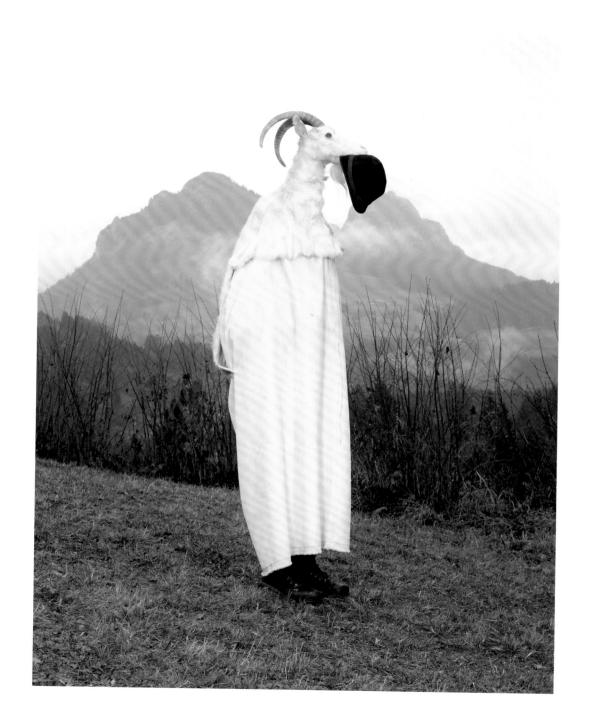

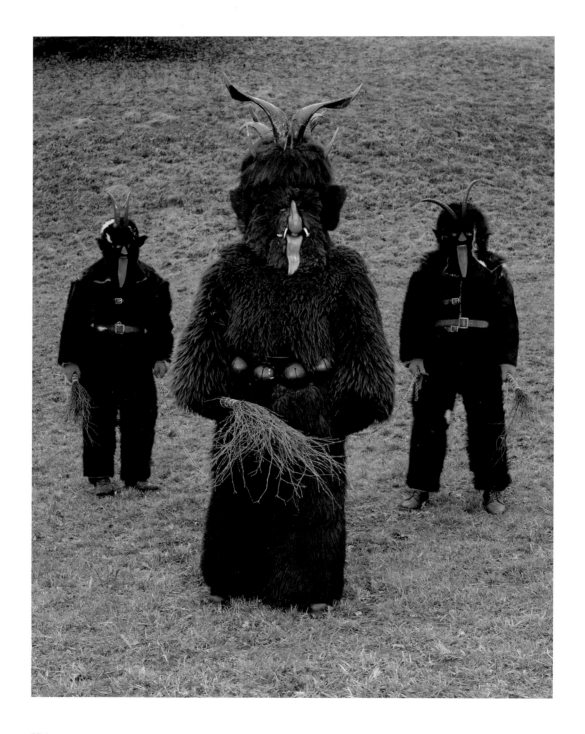

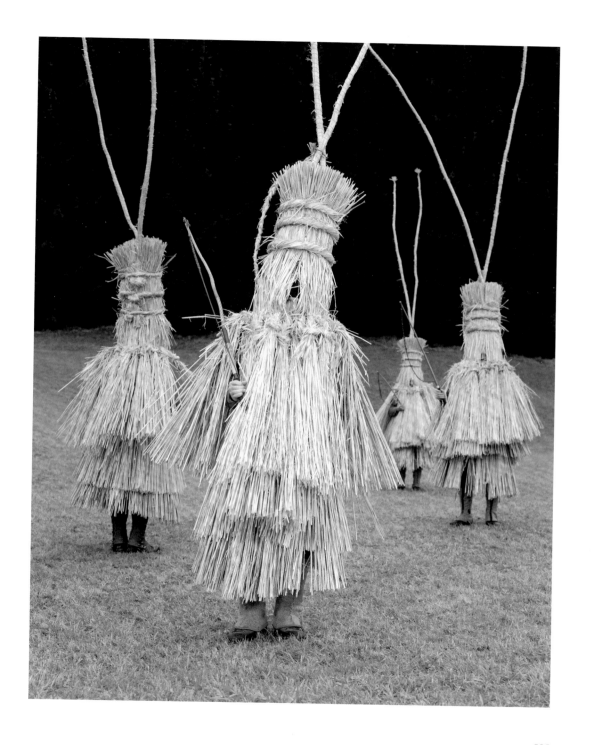

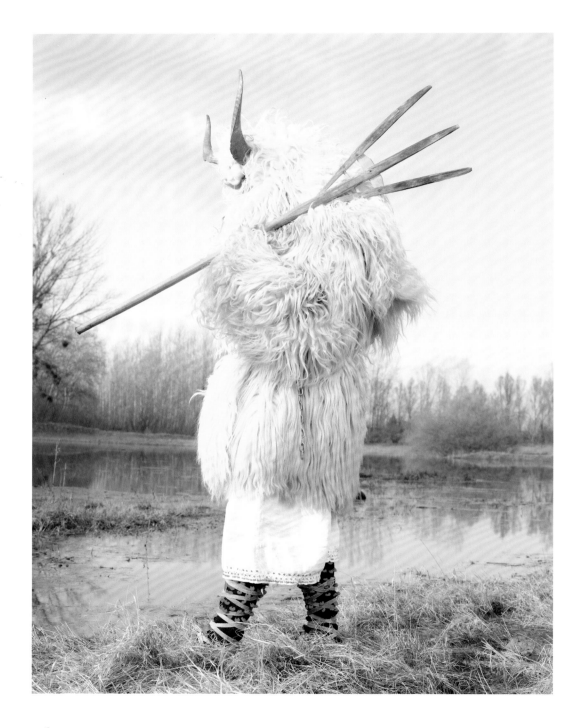

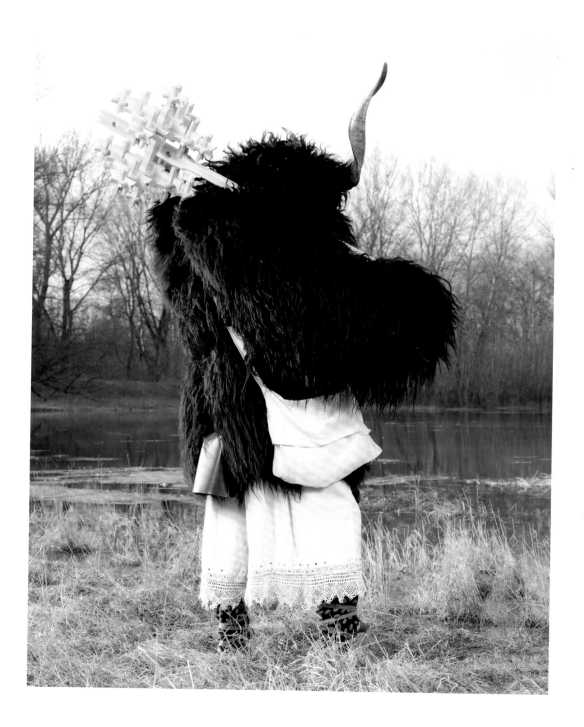

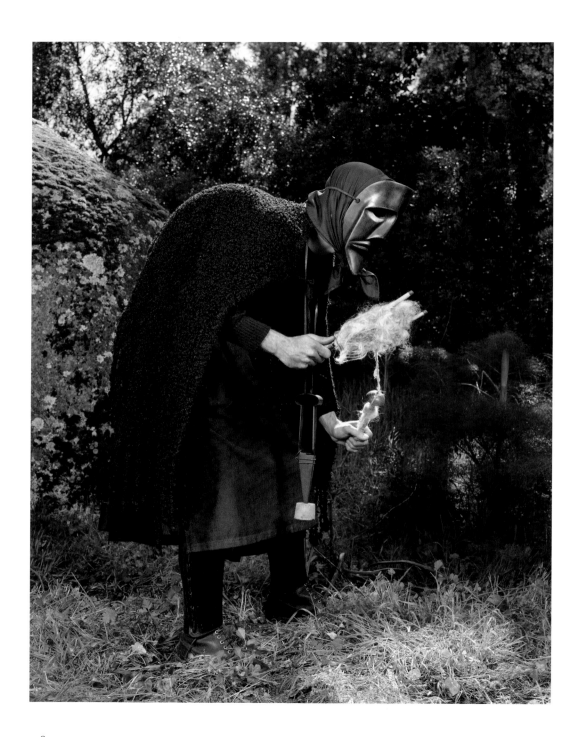

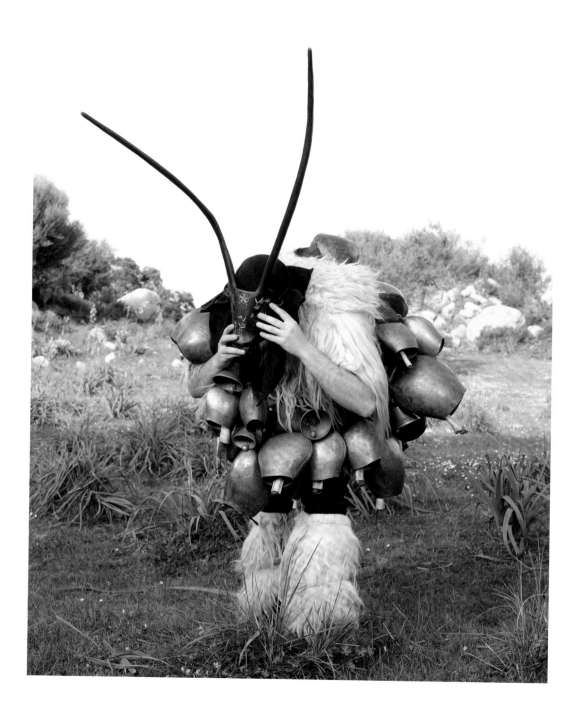

[pages 106 and 107] *Busó*, Mohács, Hungary

[page 108] *Filonzana*, Ottana, Sardinia, Italy

[previous page and opposite] *Boes*, Ottana, Sardinia, Italy

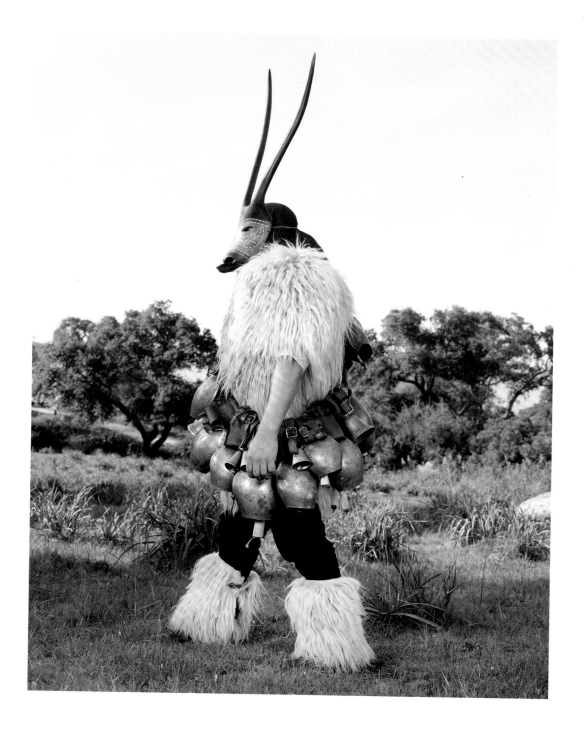

Mamuthones, Mamoiada, Sardinia, Italy

[following double page] *Cerbus*, Sinnai, Sardinia, Italy

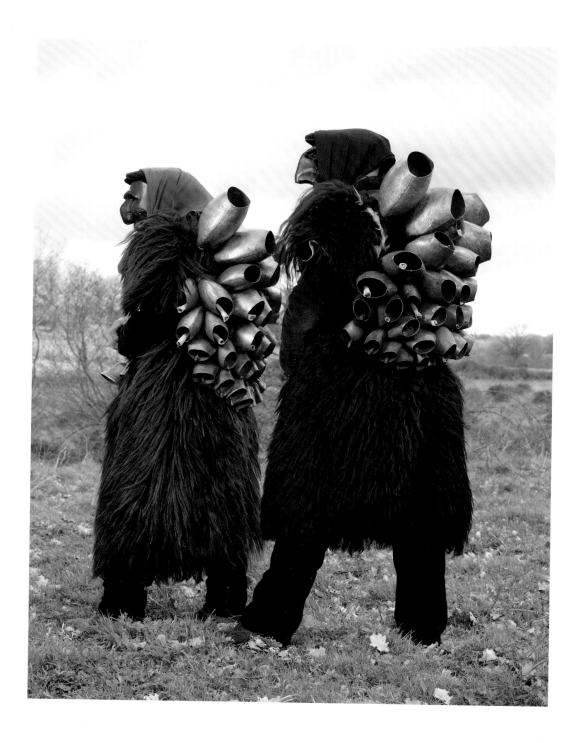

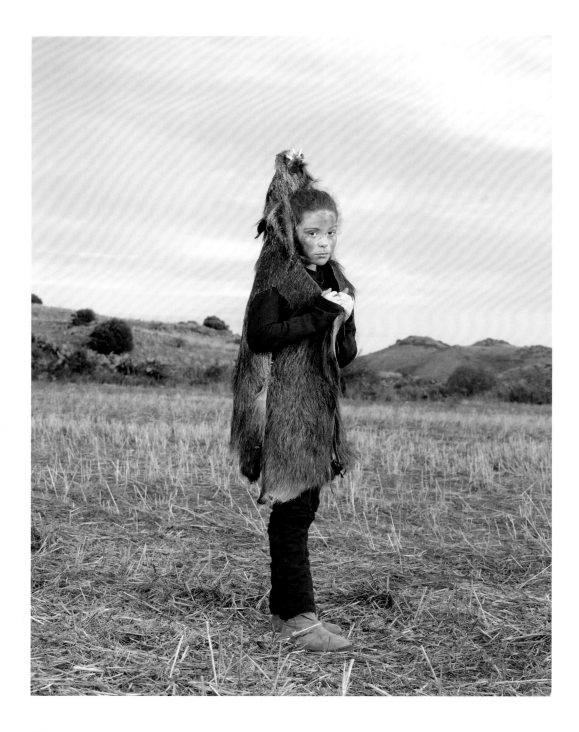

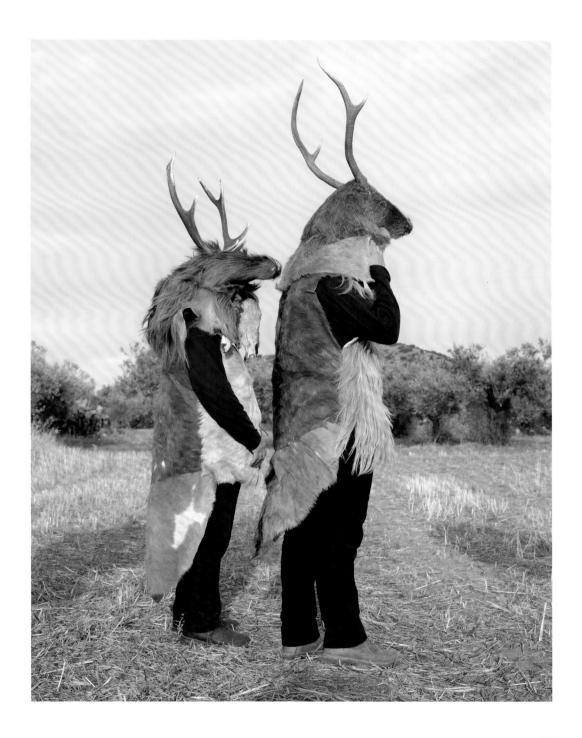

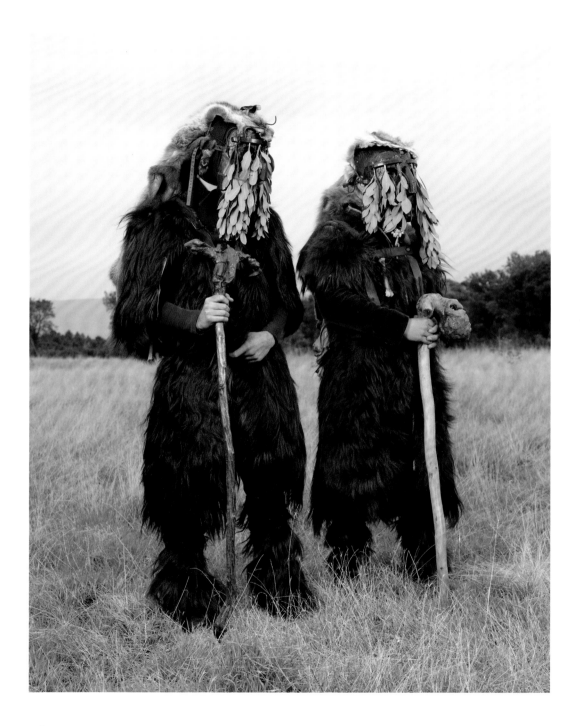

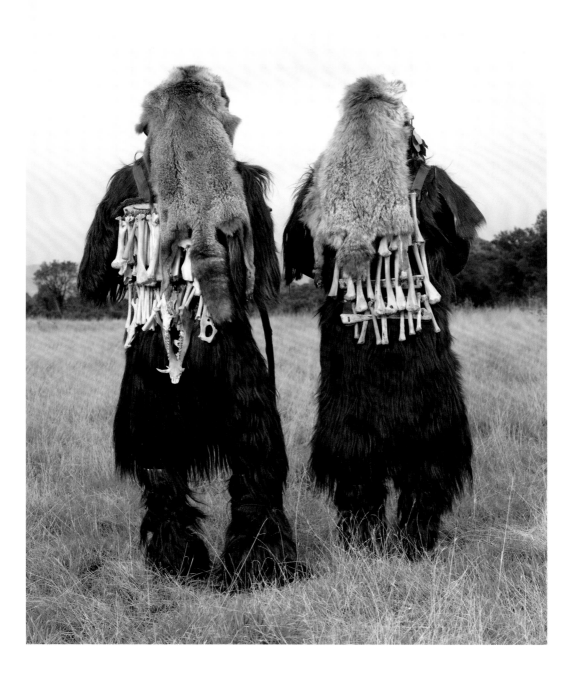

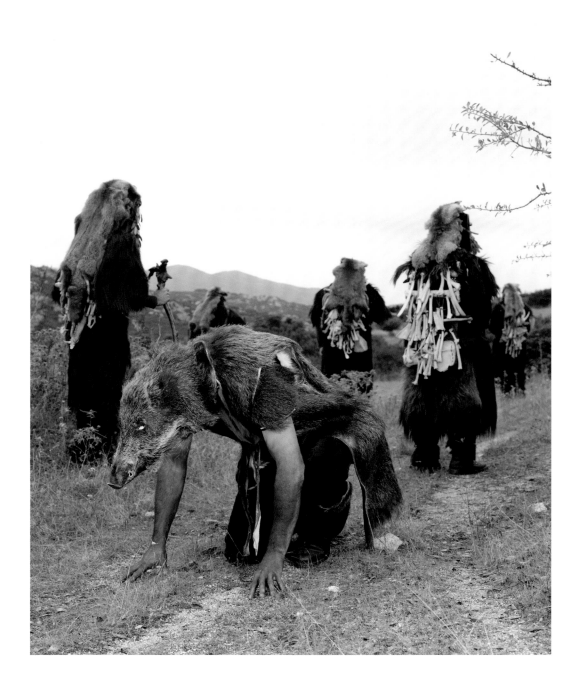

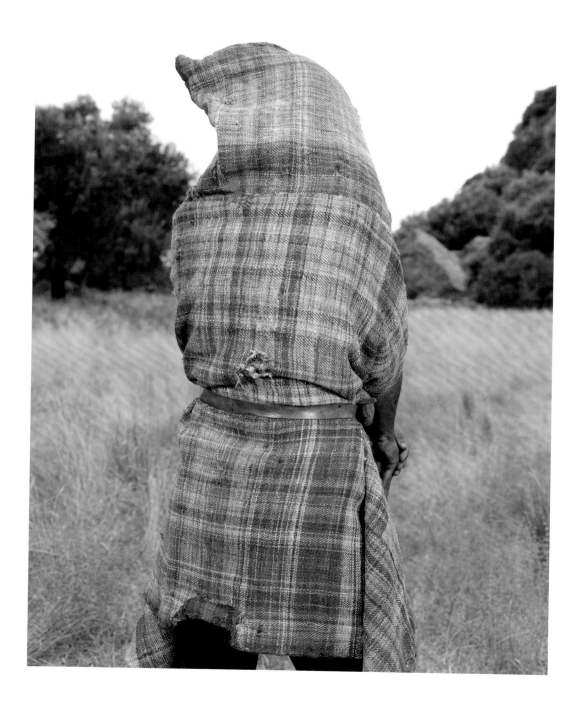

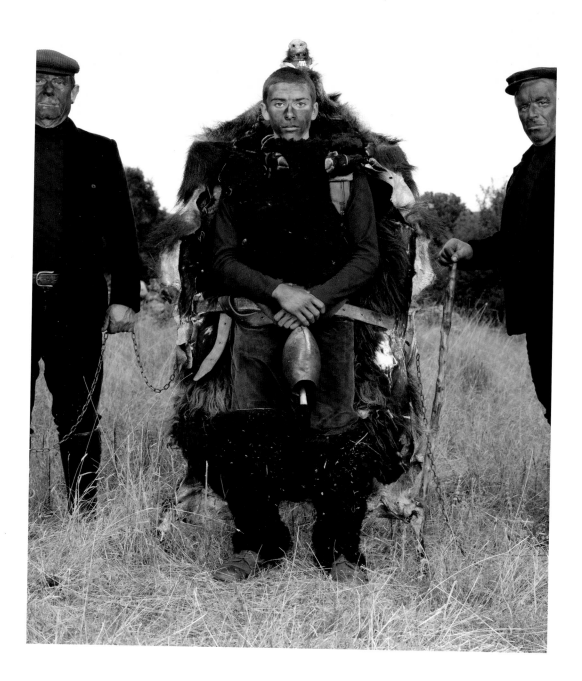

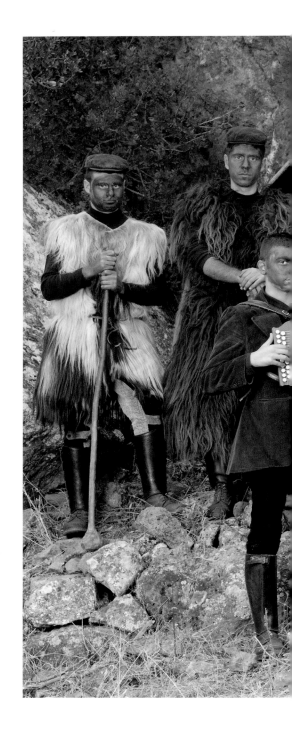

Urtzu and *Bardianos*, Ulà Tirso, Sardinia, Italy

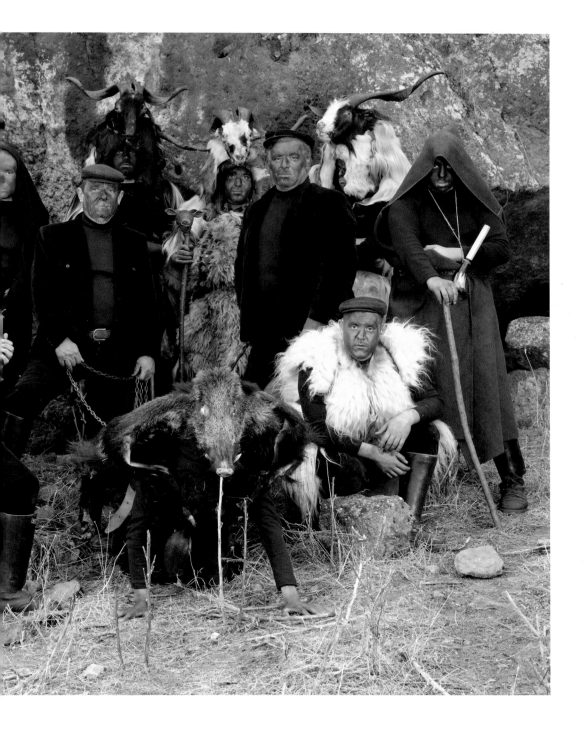

Maschingannas, Ulà Tirso, Sardinia, Italy

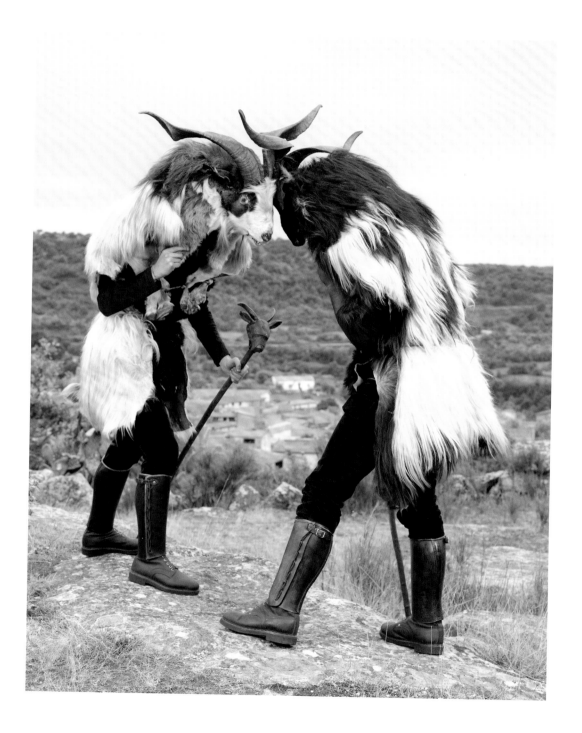

Sonaggiao, Ortueri, Sardinia, Italy

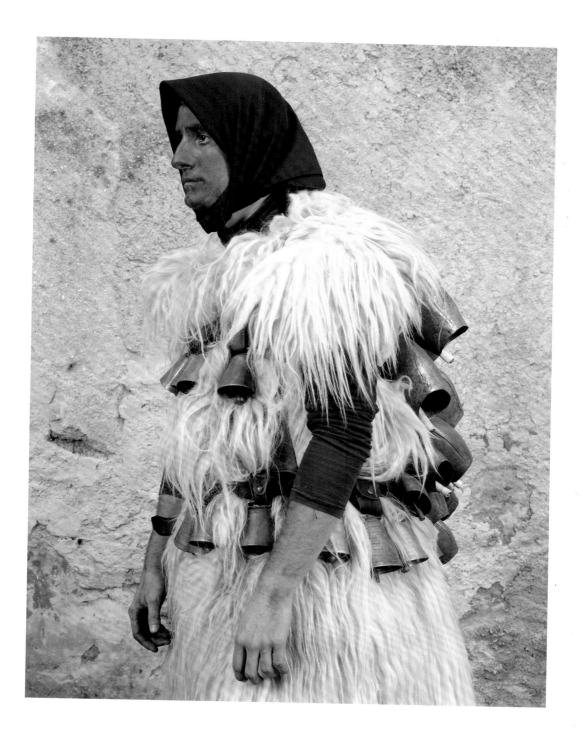

Sonaggiaos, Ortueri, Sardinia, Italy

[following double page] *Sonaggiao* and *Urtzu*; *Sonaggiao*, Ortueri, Sardinia, Italy

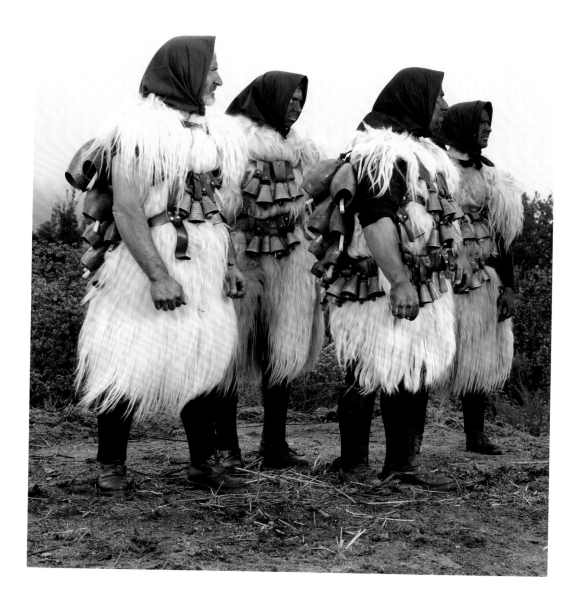

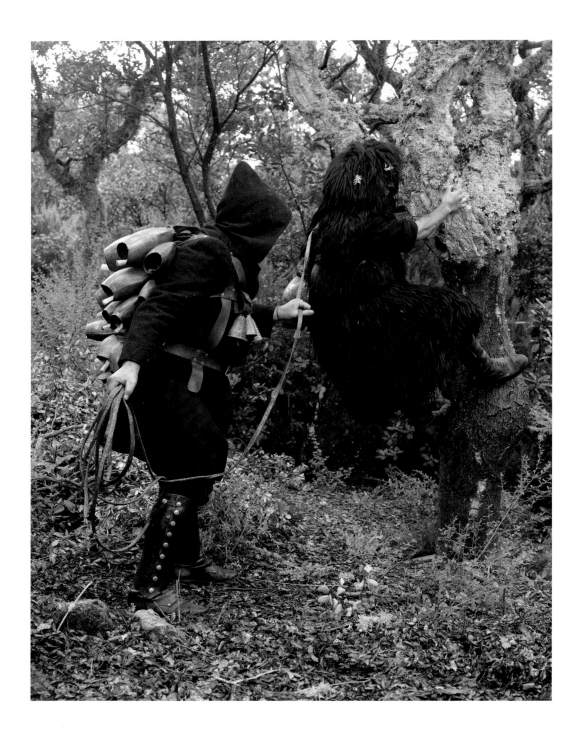

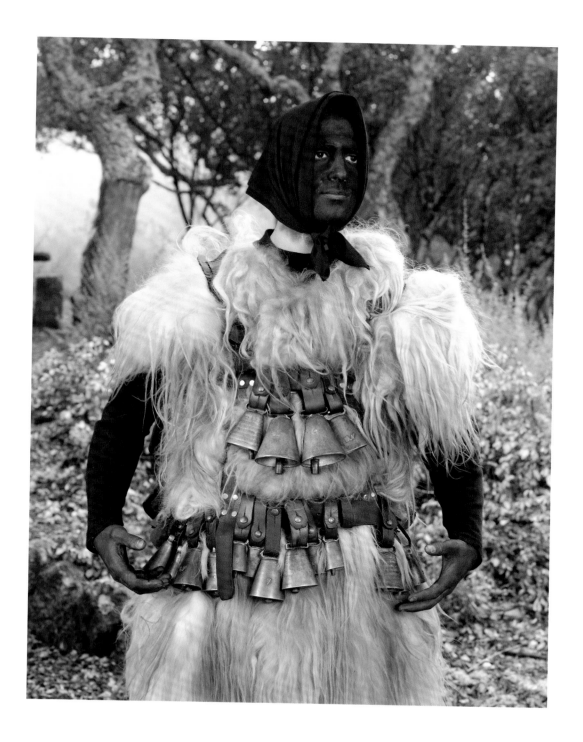

Mamutzone, Samugheo, Sardinia, Italy

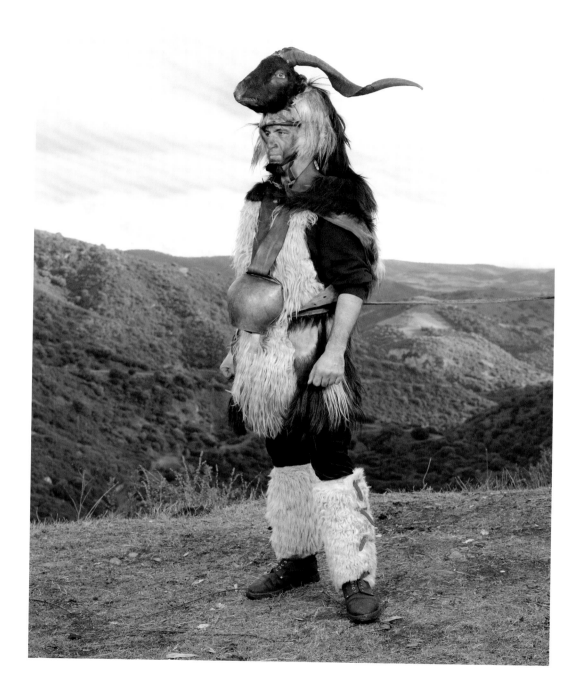

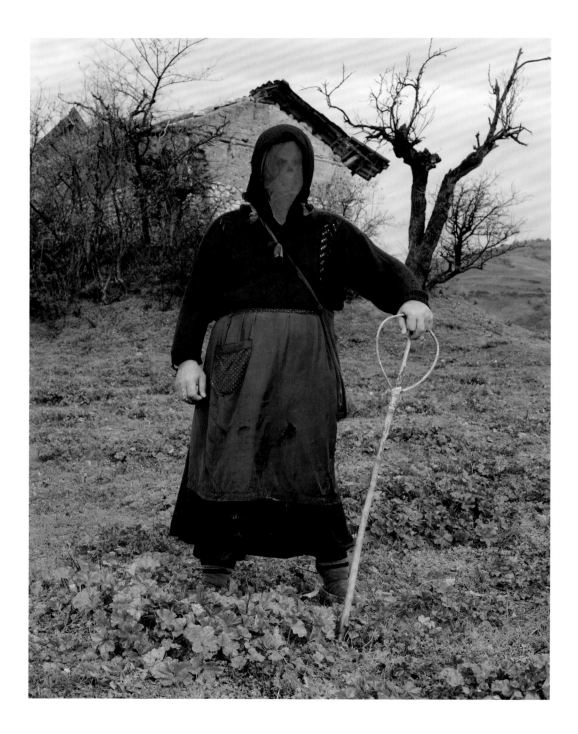

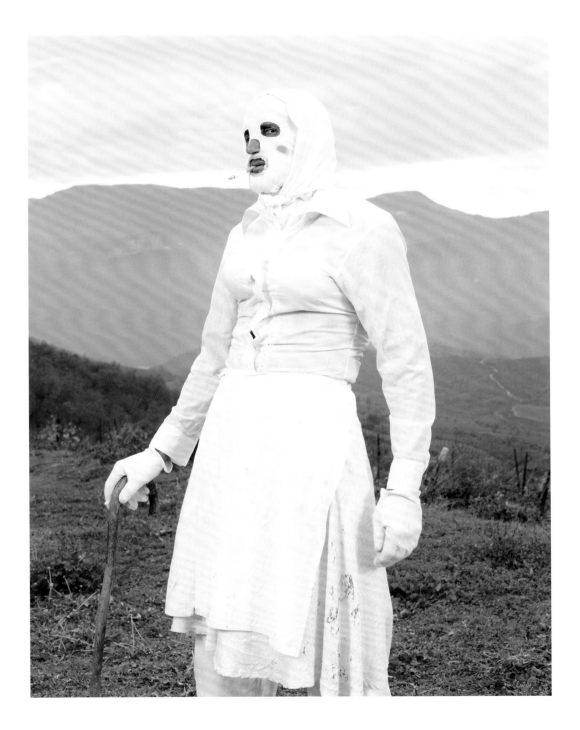

[previous double page] *Baba* and *Nevesta*, Begnishte, Macedonia

Djolomari, Begnishte, Macedonia

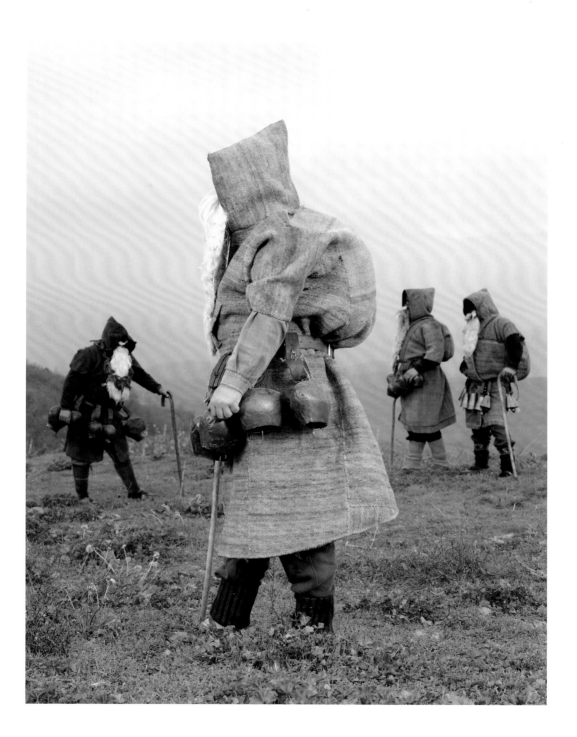

Djolomari, Begnishte, Macedonia

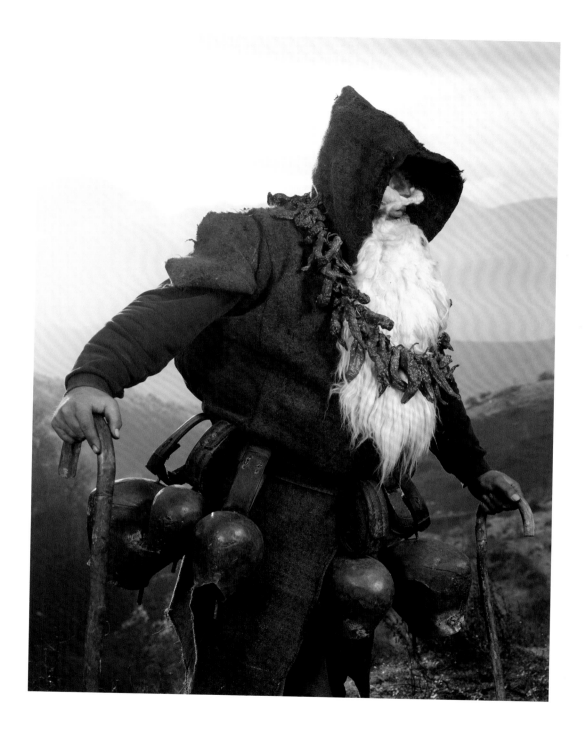

Djolomari, Begnishte, Macedonia

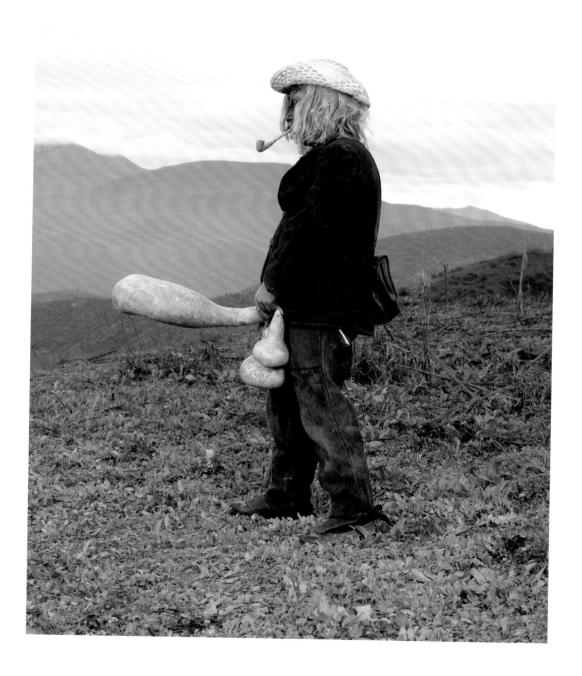

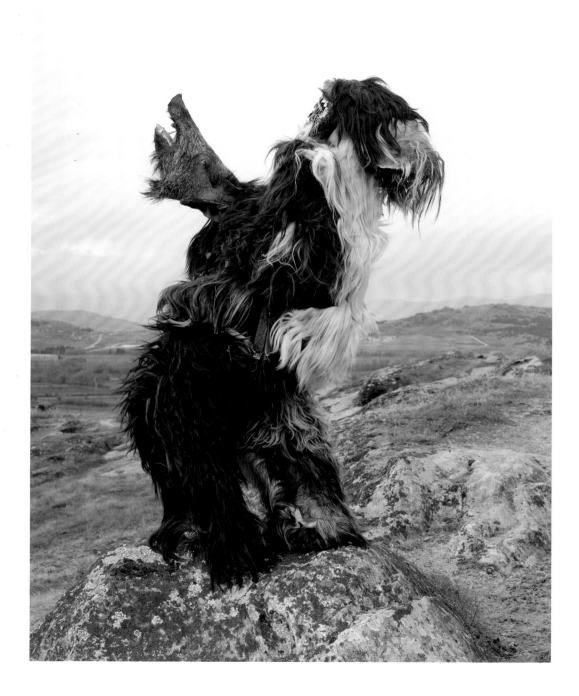

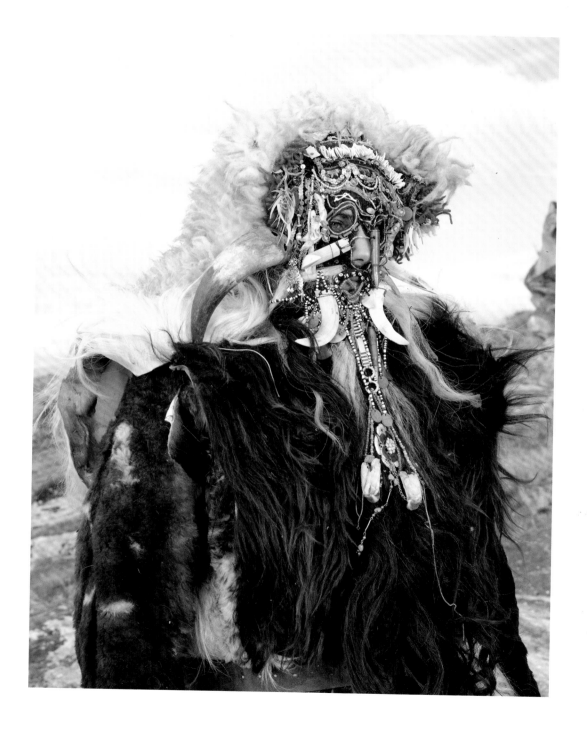

[previous double page and opposite] *Mechkari*, Prilep, Macedonia

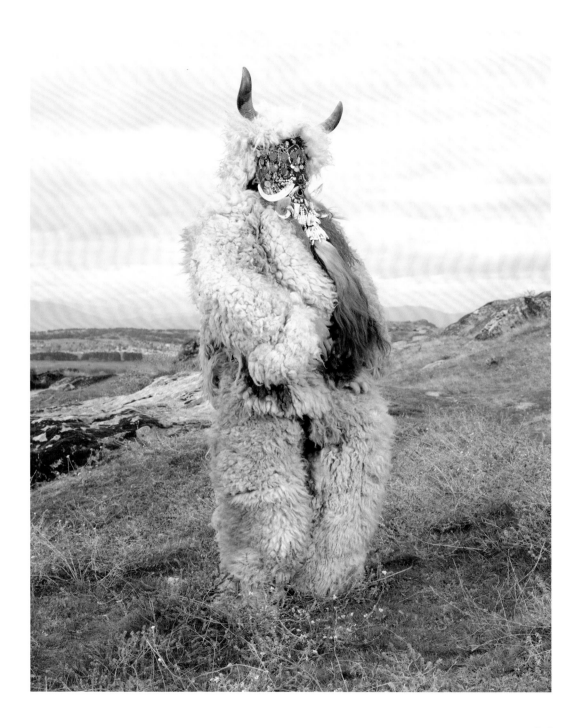

[opposite and following double page] *Babugeri*, Bansko, Bulgaria

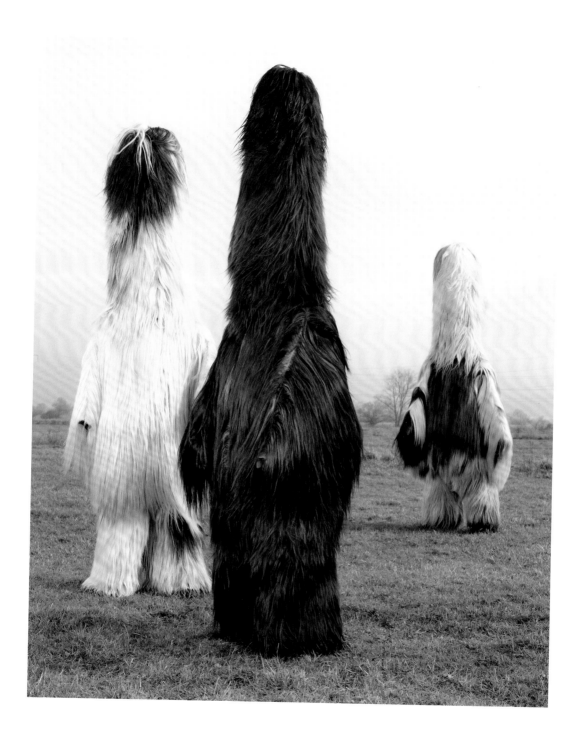

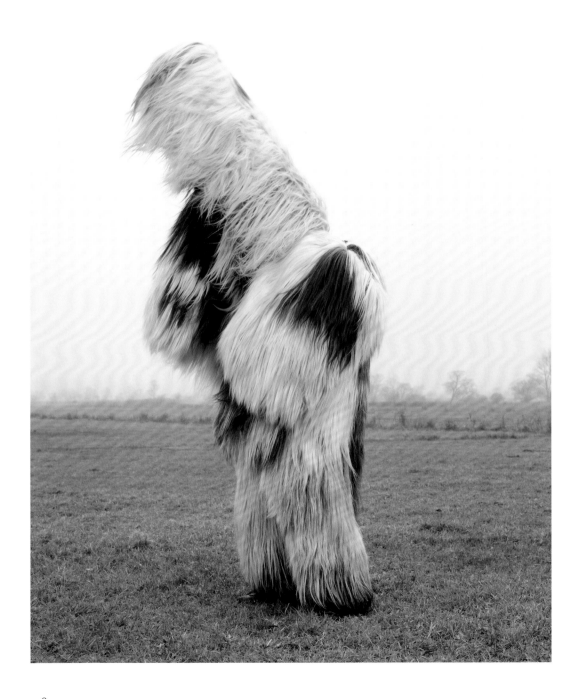

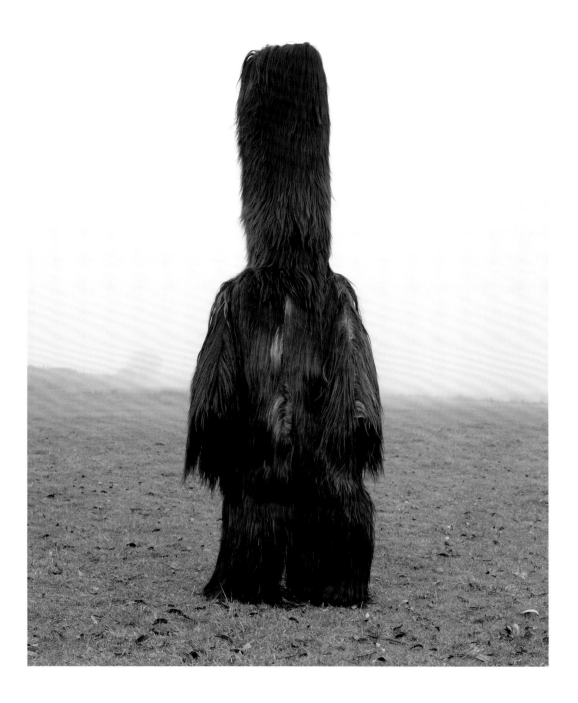

Chaushi, Razlog, Bulgaria

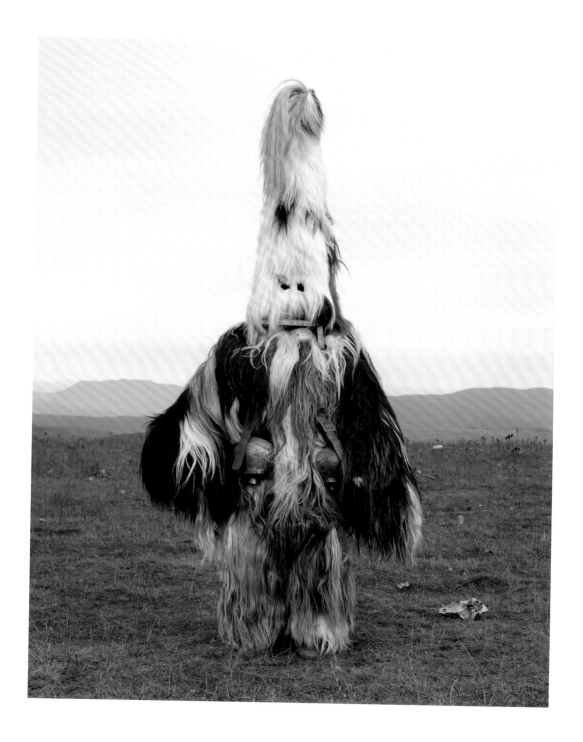

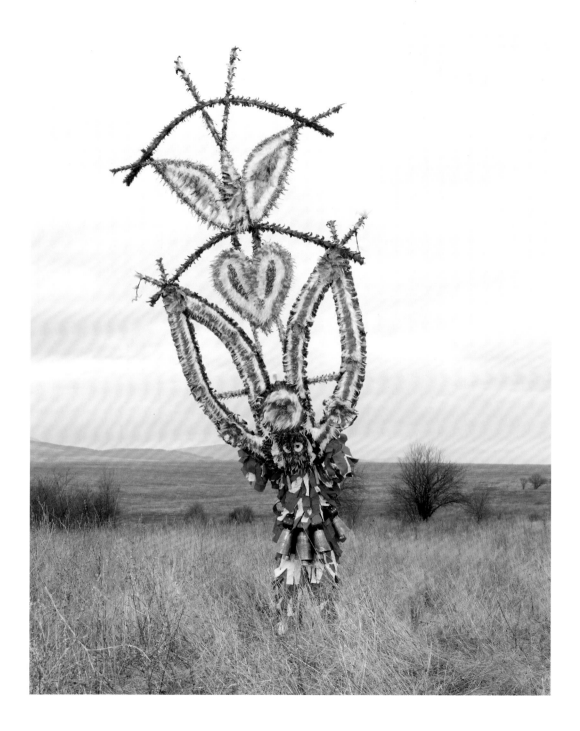

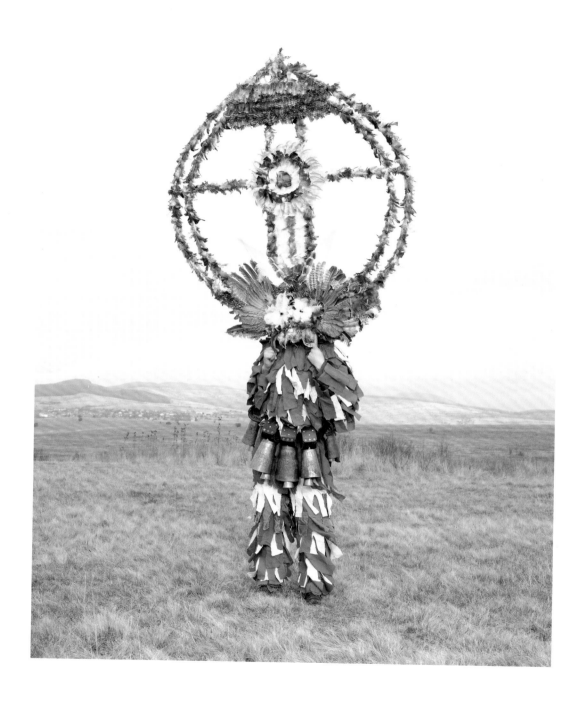

[previous double page and opposite] *Sourvakari*, Gabrov dol, Bulgaria

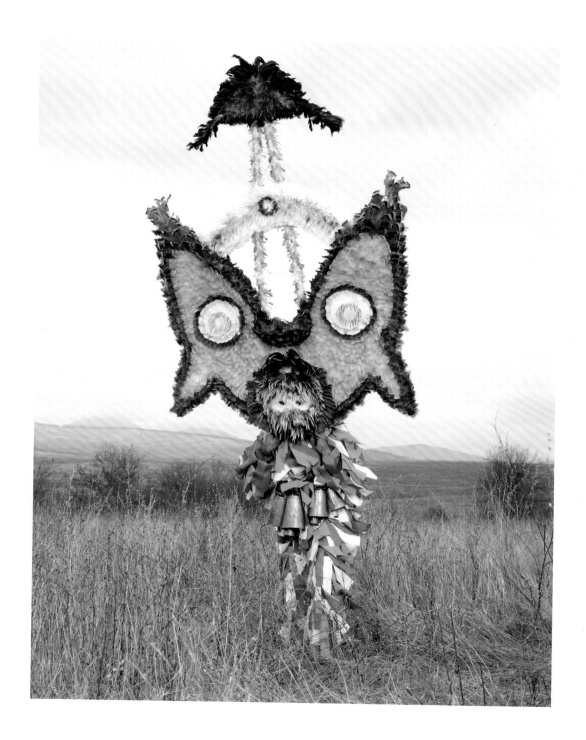

Bear, Banishte, Bulgaria

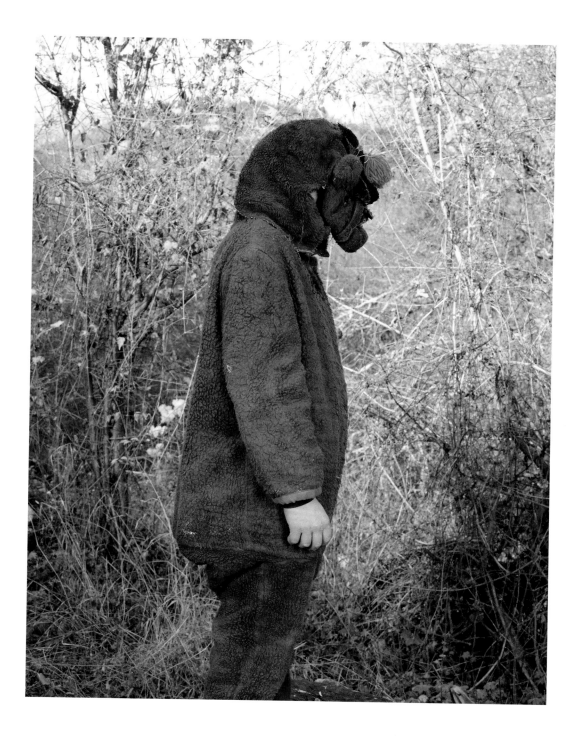

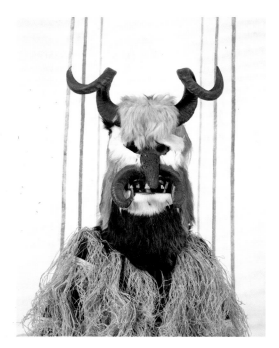
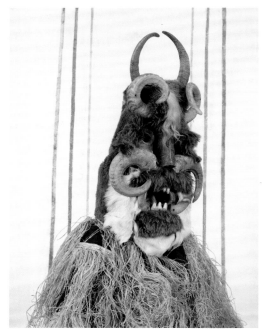
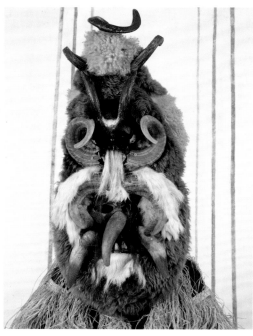
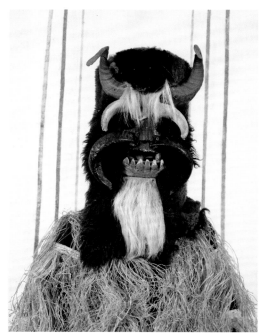

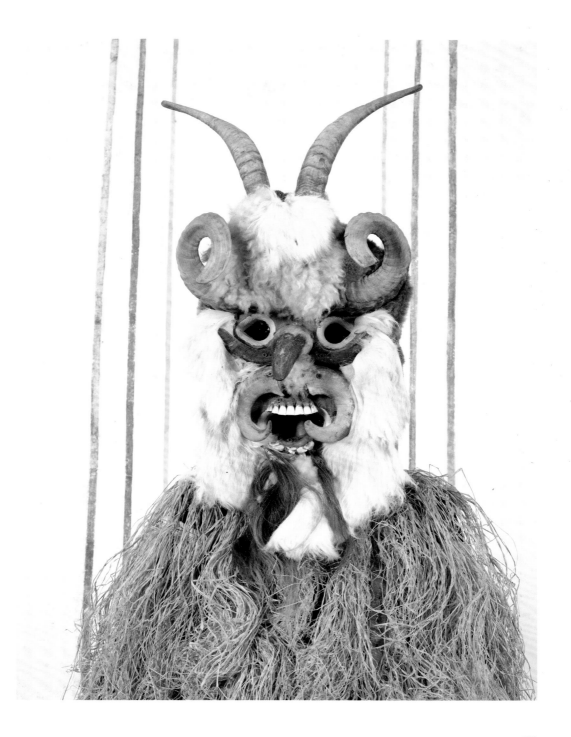

[previous double page and opposite] *Sourvakari*, Banishte, Bulgaria

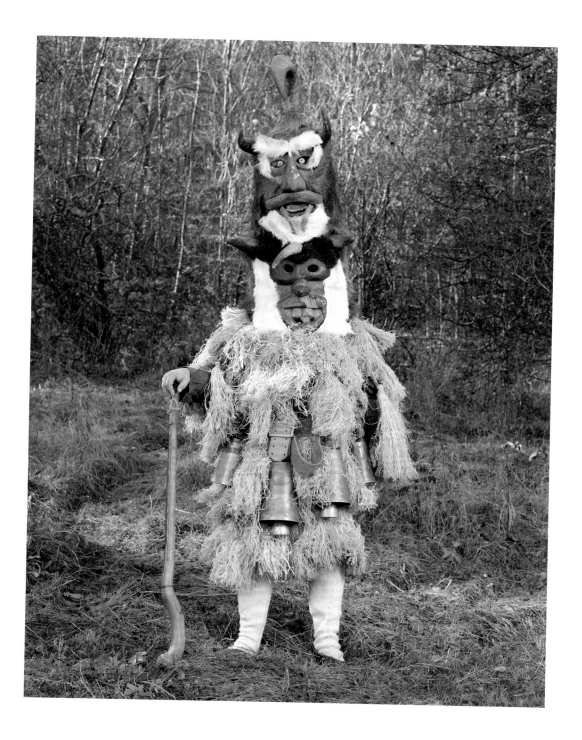

[opposite and following double page] *Sourvakari*, Banishte, Bulgaria

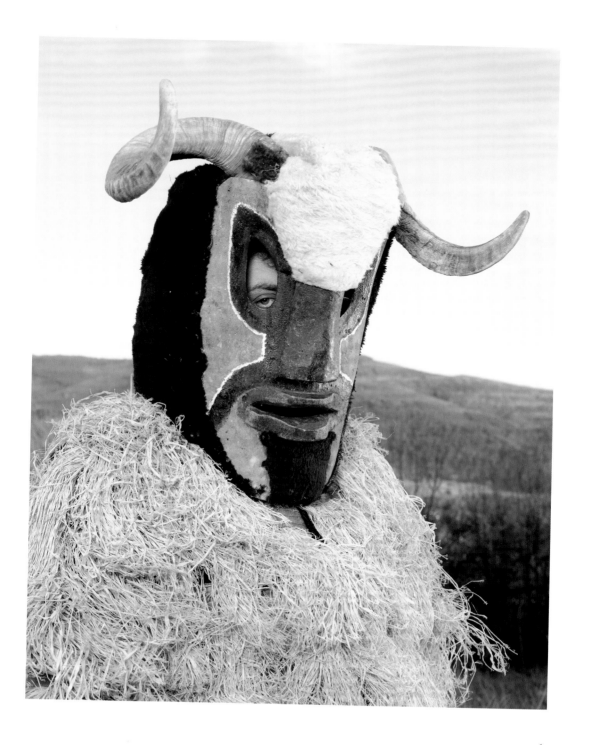

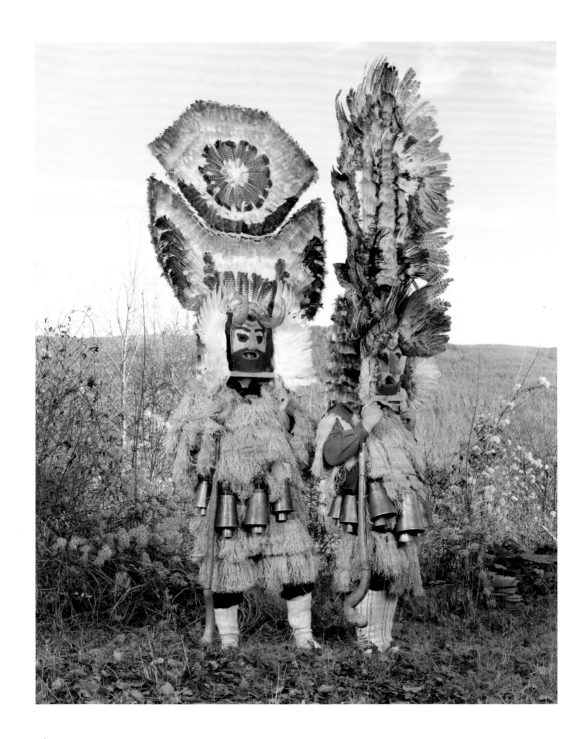

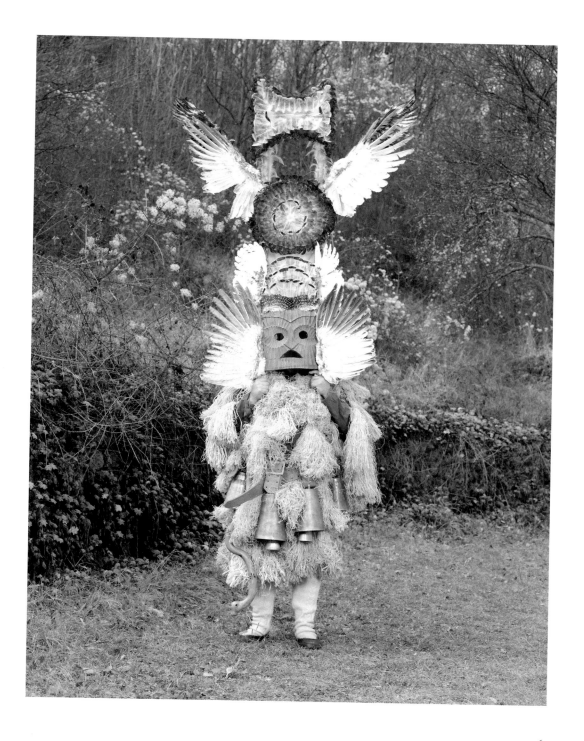

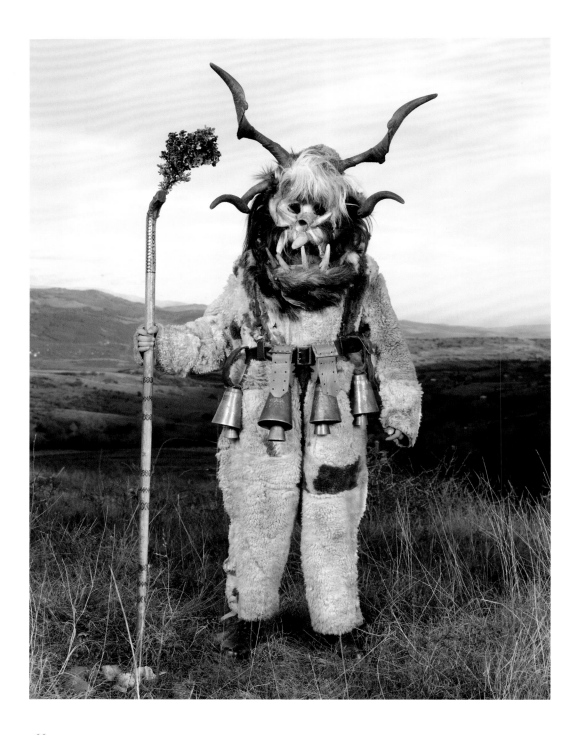

166

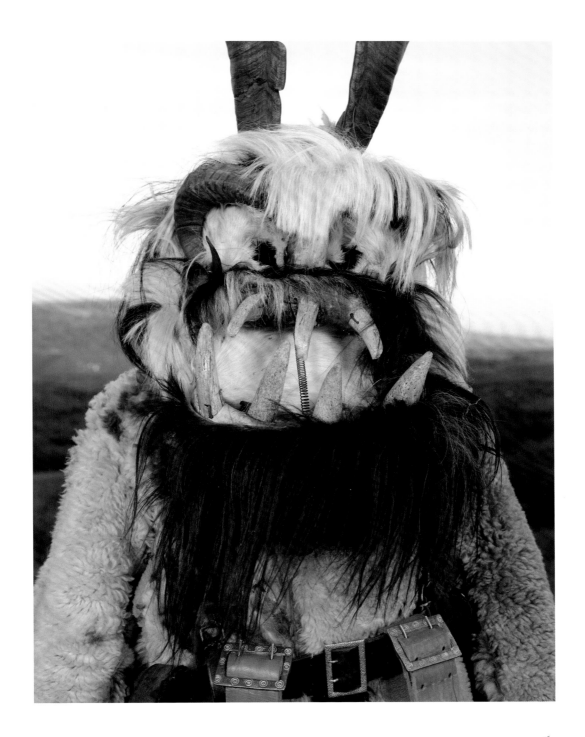

[previous double page] *Sourvakari*, Leskovets, Bulgaria

[opposite and following page] *Arapides*, Monastiraki, Greece

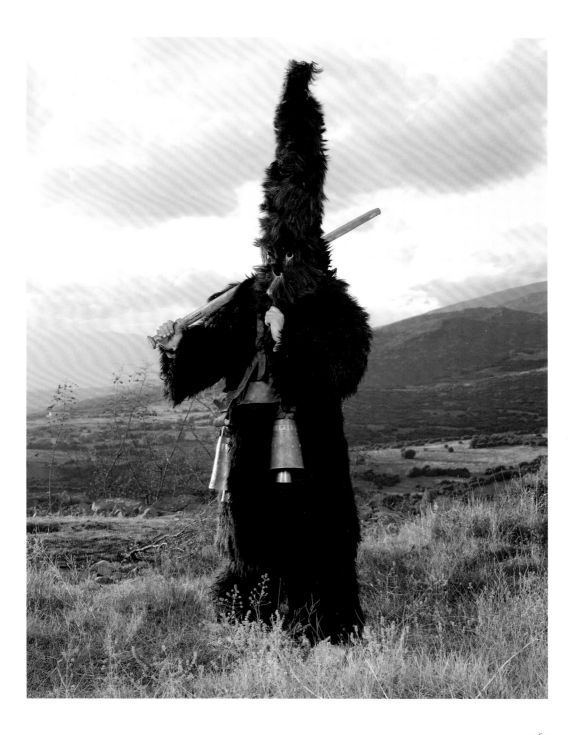

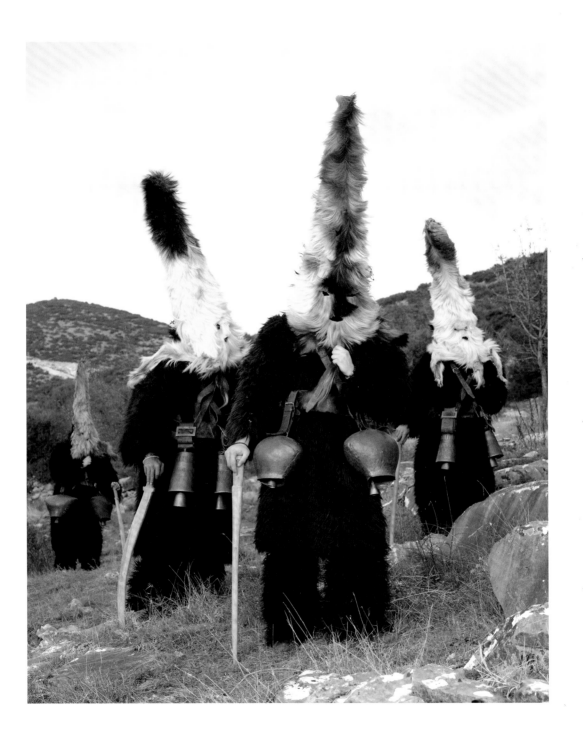

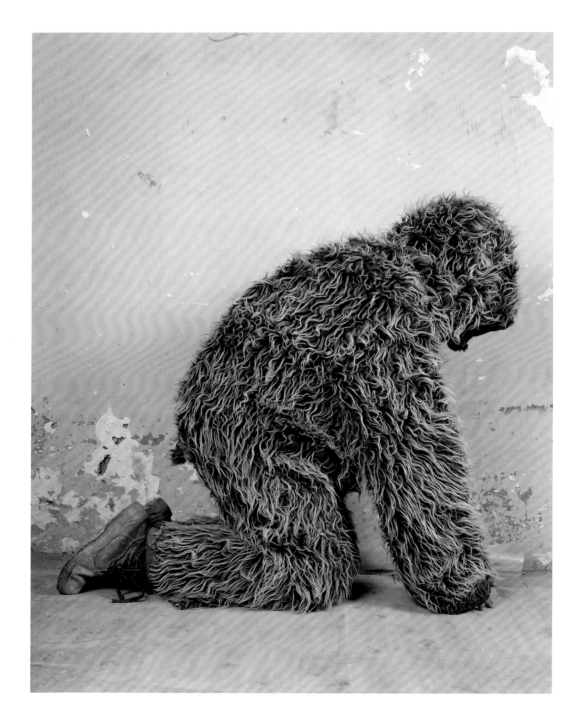

Arkouda (Bear), Monastiraki, Greece

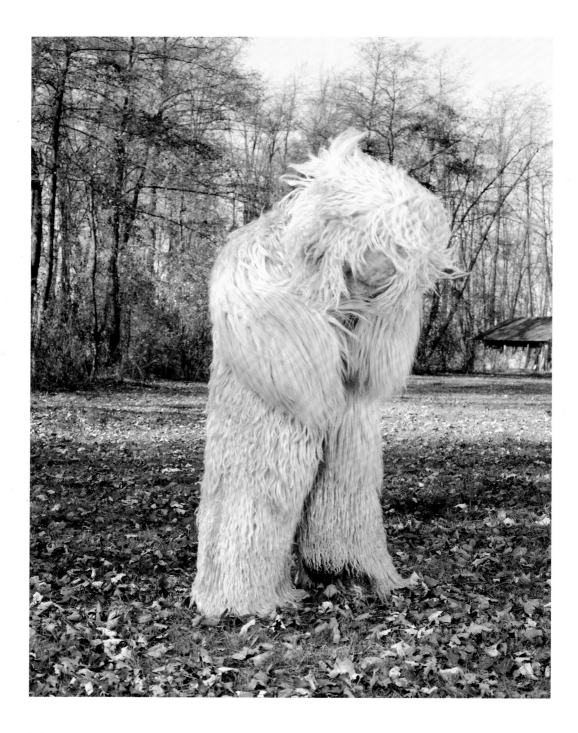

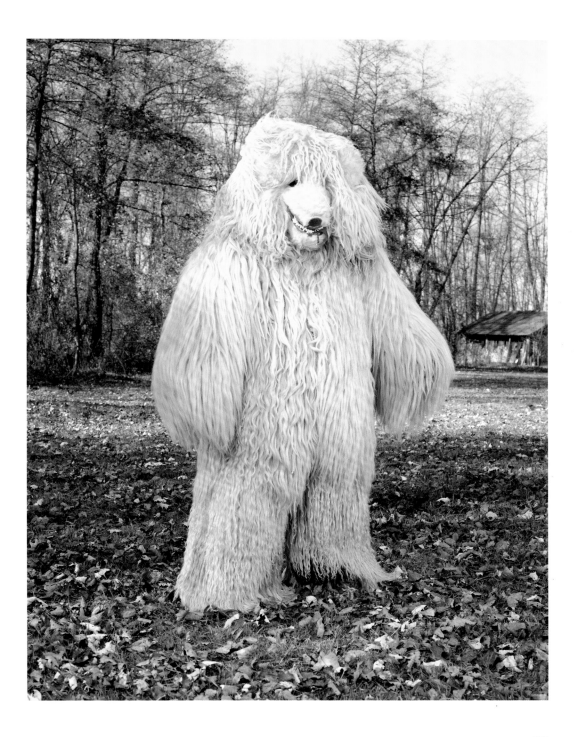

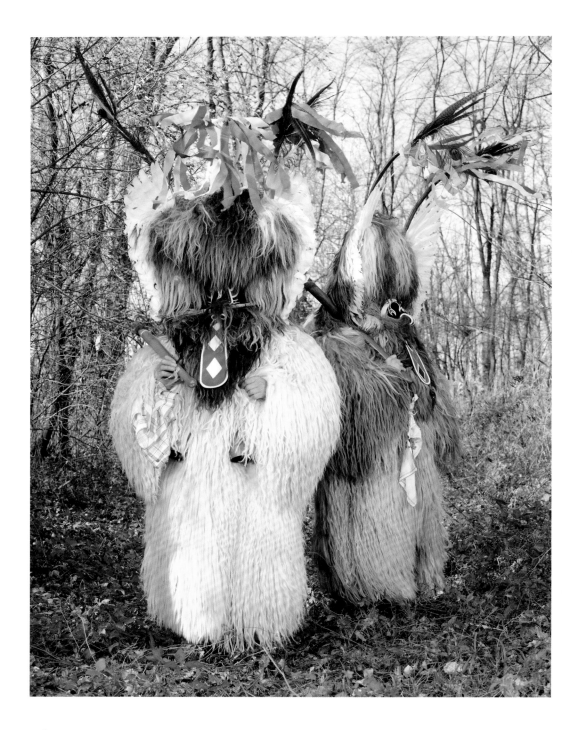

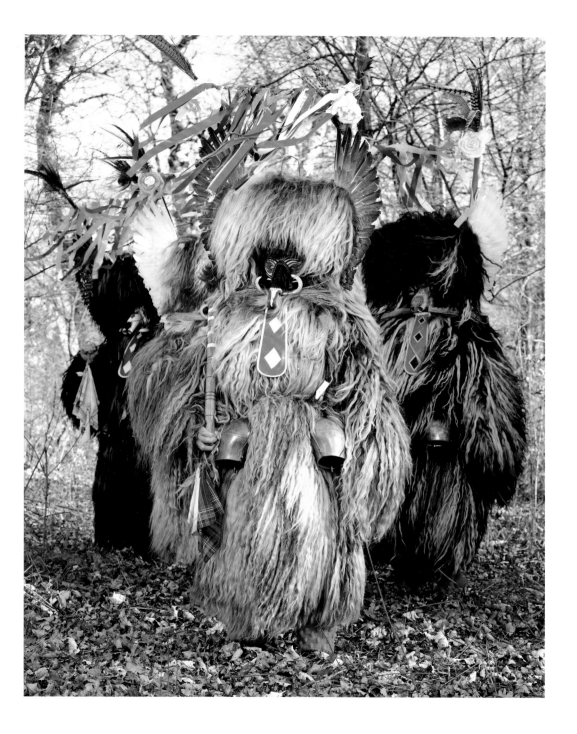

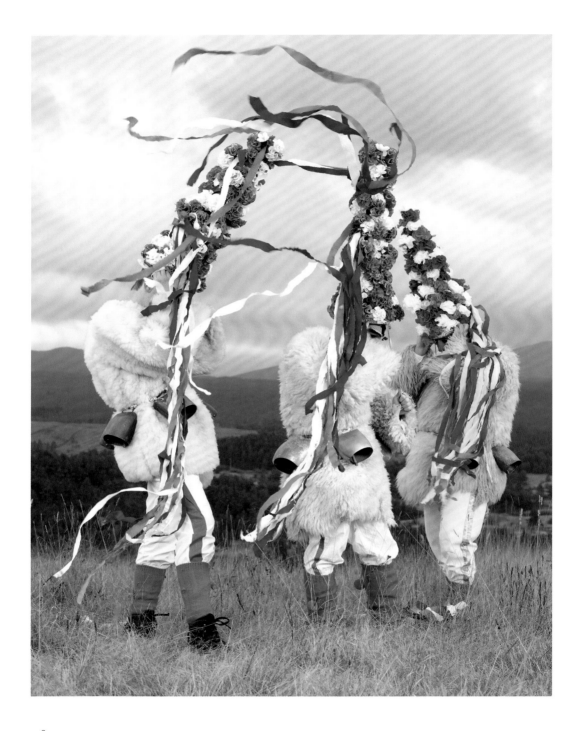

[pages 174 and 175] *Medved* (Bear), Ptuj, Slovenia

[previous double page] *Kurenti*, Ptuj, Slovenia

Škoromati, Podgrad, Slovenia

Trapo, Zarramacadas of Mecerreyes, Spain

[following double page] *Colono* and *Hueso*, Zarramacadas of Mecerreyes, Spain

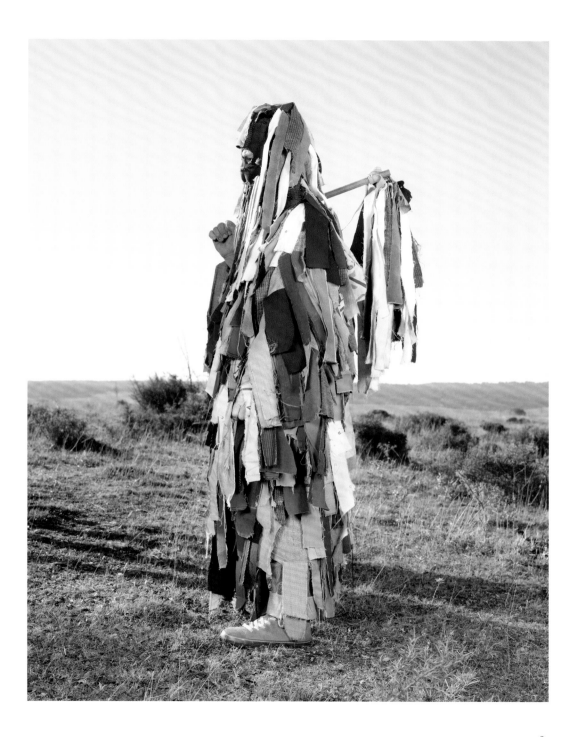

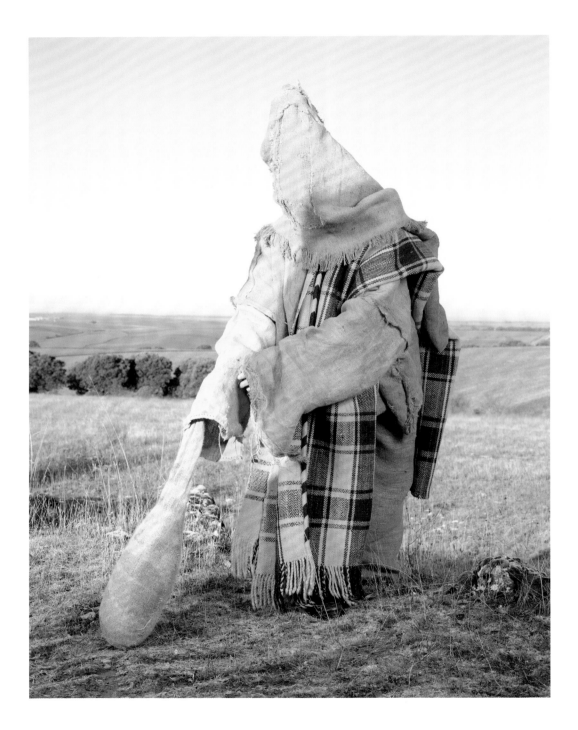

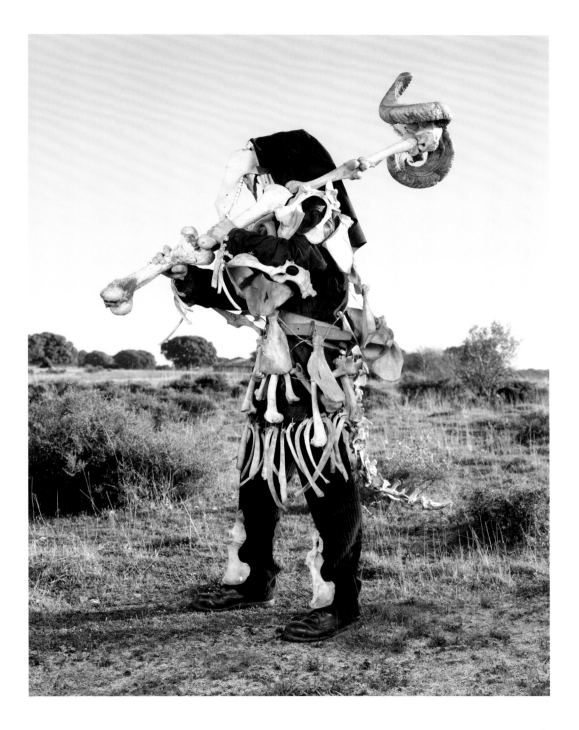

Gallarone, Zarramacadas of Mecerreyes, Spain

[following double page] *Pluma* and *Tras de cuerdas*, Zarramacadas of Mecerreyes, Spain

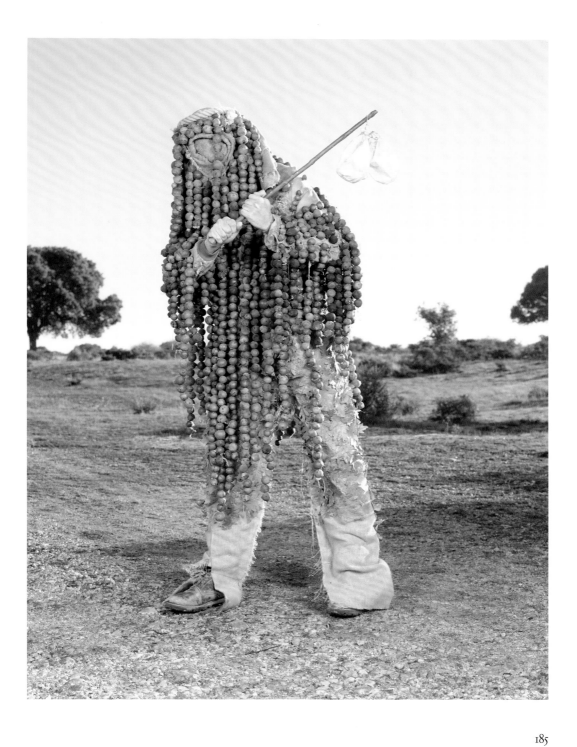

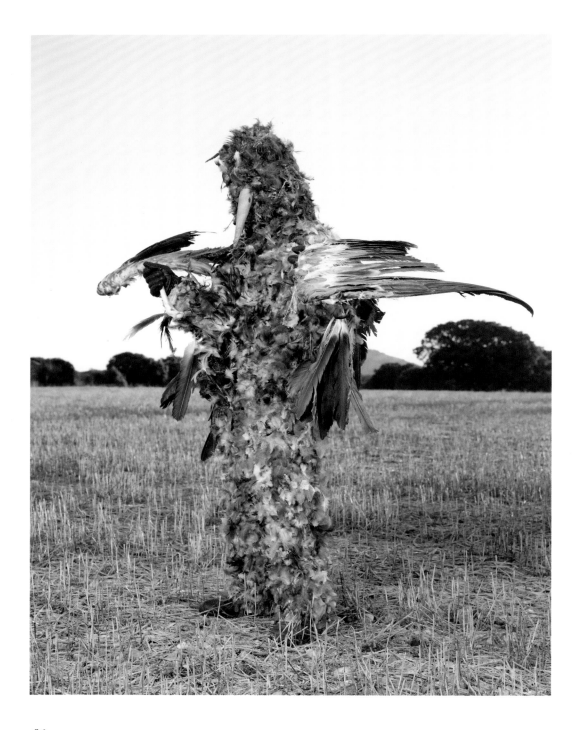

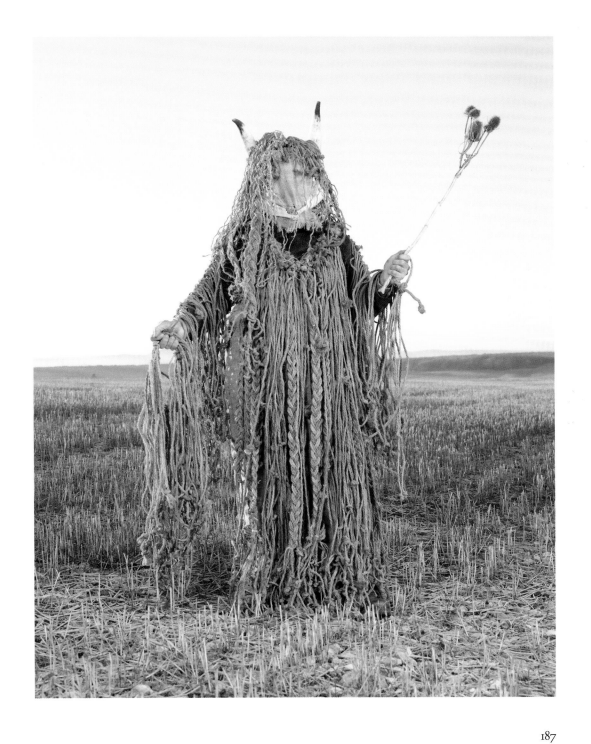

Oso (Bear), Zarramacadas of Mecerreyes, Spain

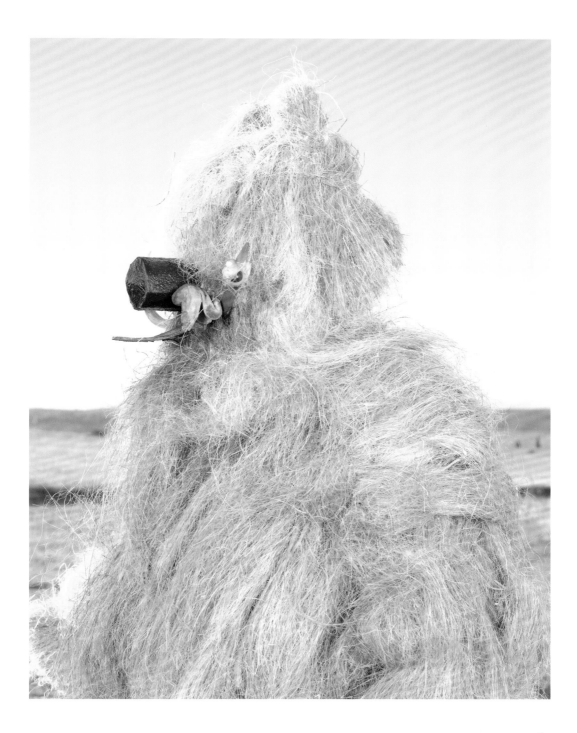

Carnero en Zancos, Zarramacadas of Mecerreyes, Spain

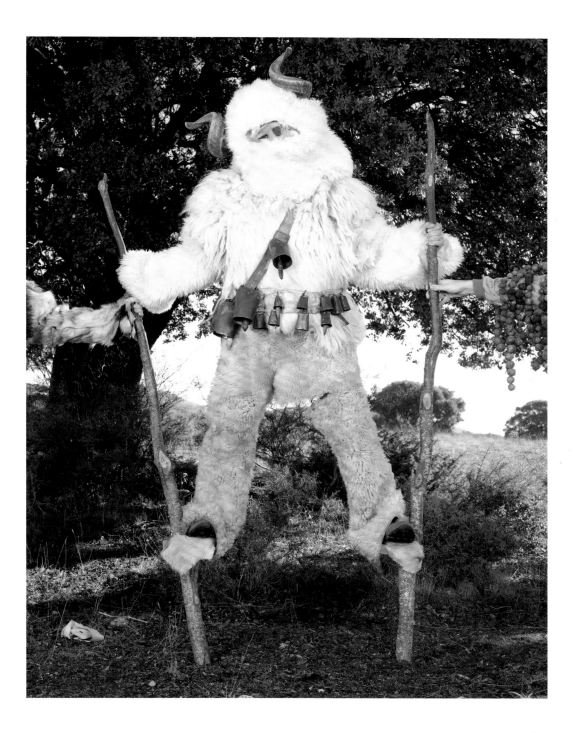

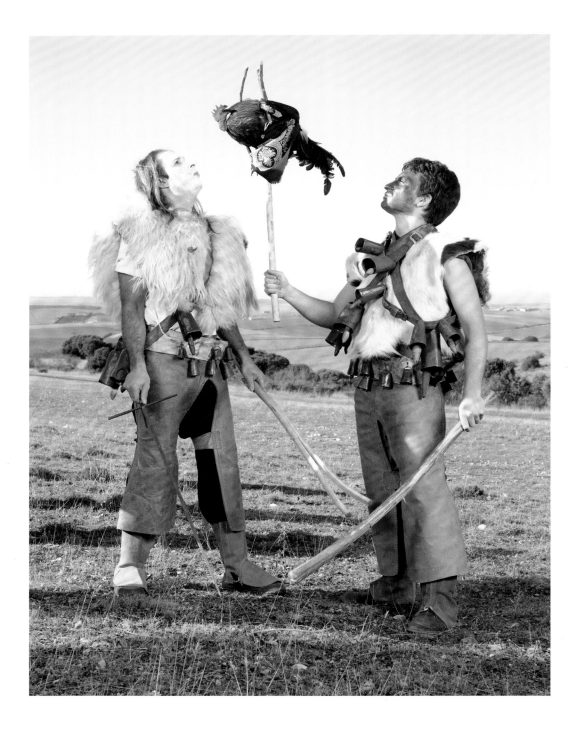

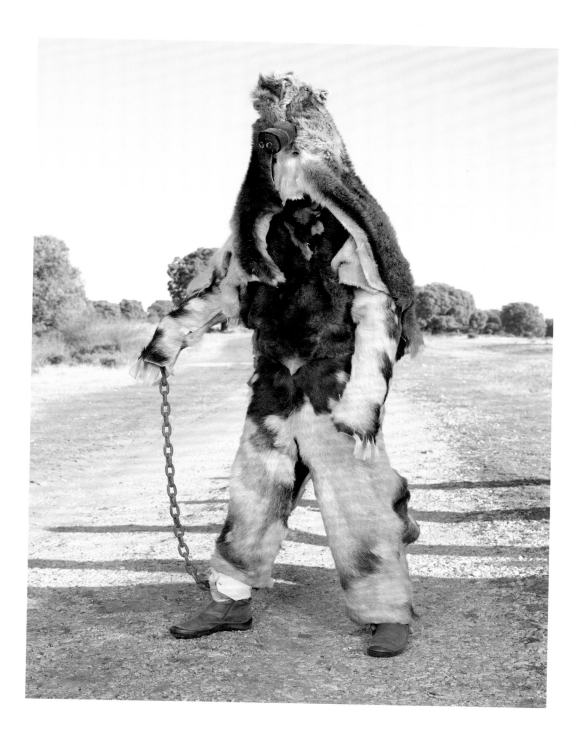

[previous double page] *Zarramacos* and *Centeno Pata*, Zarramacadas of Mecerreyes, Spain

Musgo Musgo, Zarramacadas of Mecerreyes, Spain

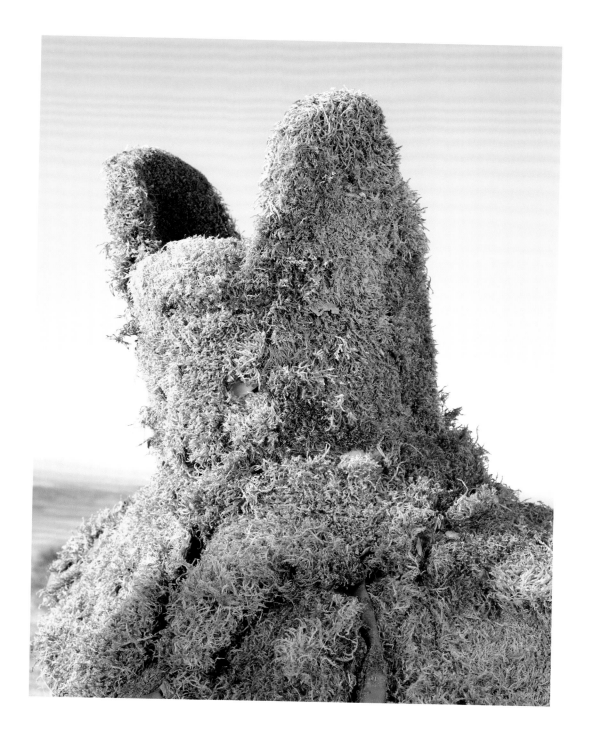

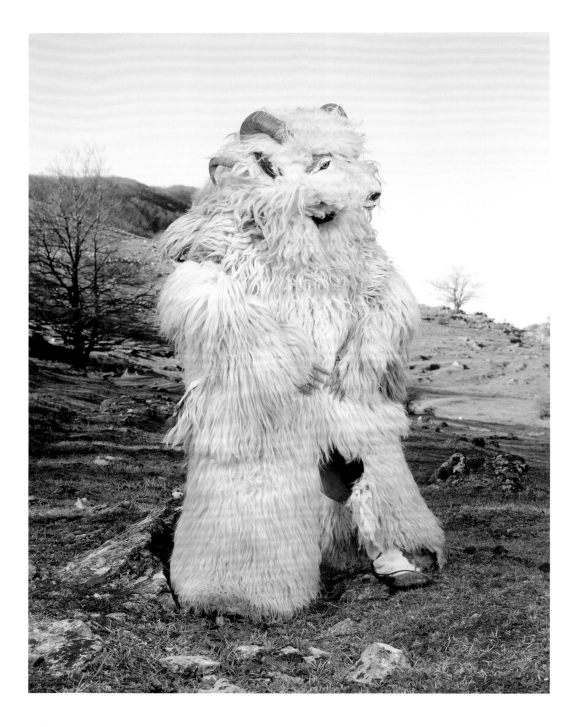

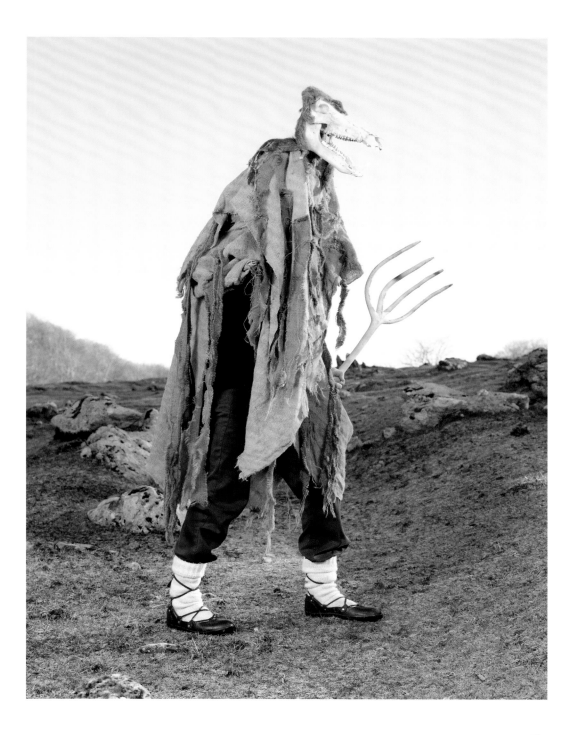

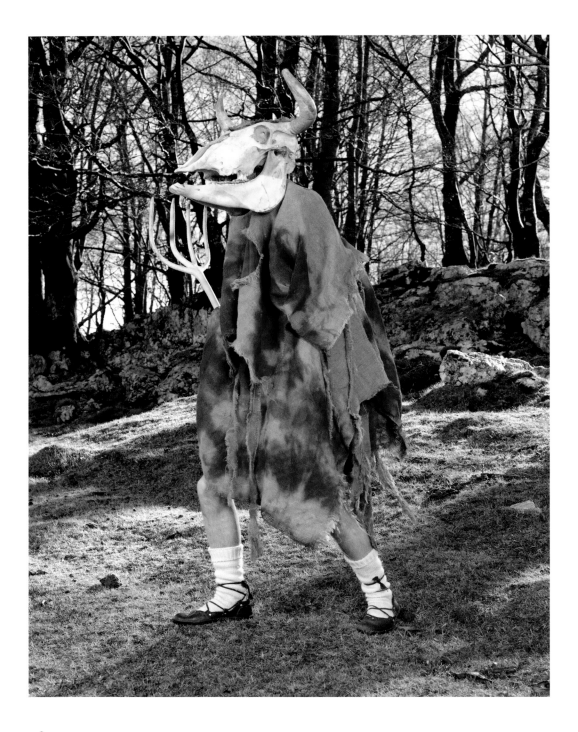

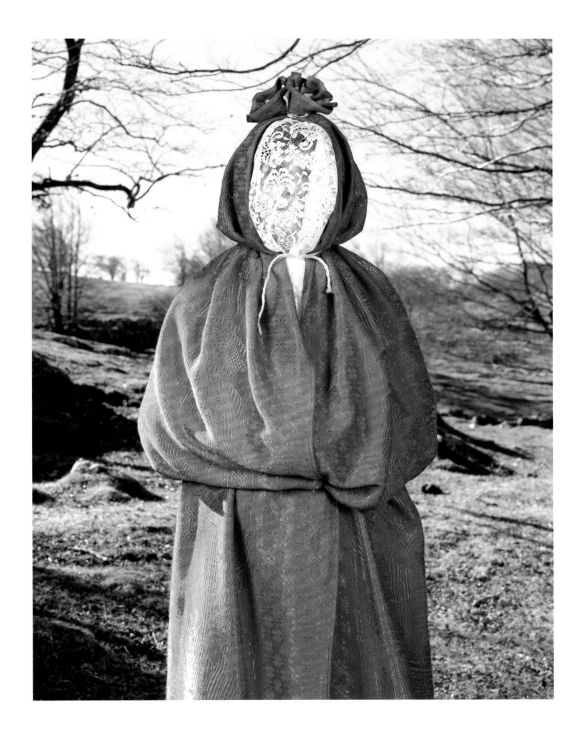

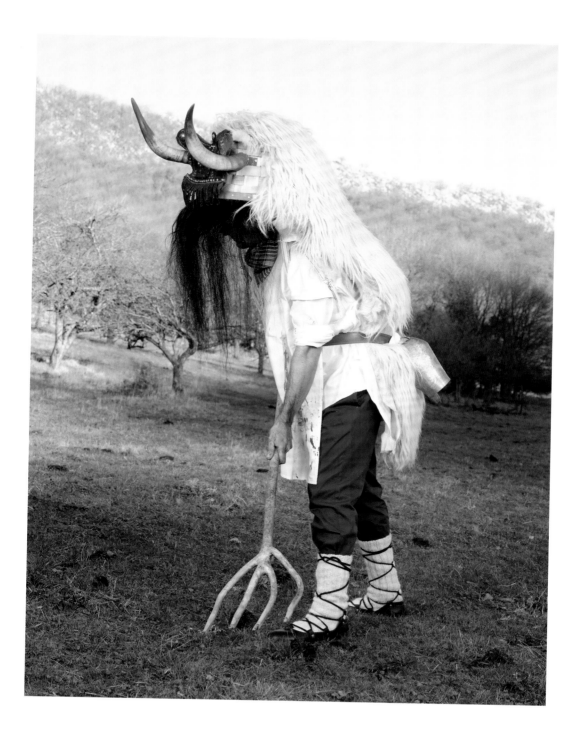

Juantramposo, Alsasua, Basque Country, Spain

[following double pages] *Zarramacos* and *Trapajones*, Silió, Spain

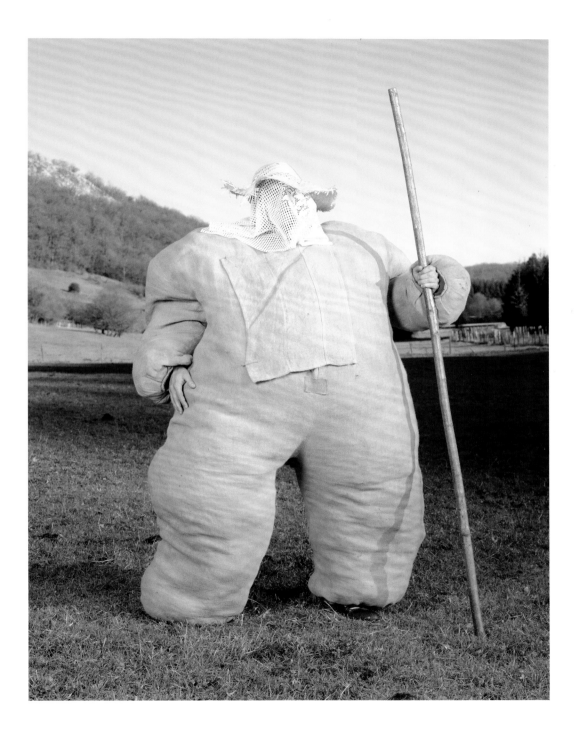

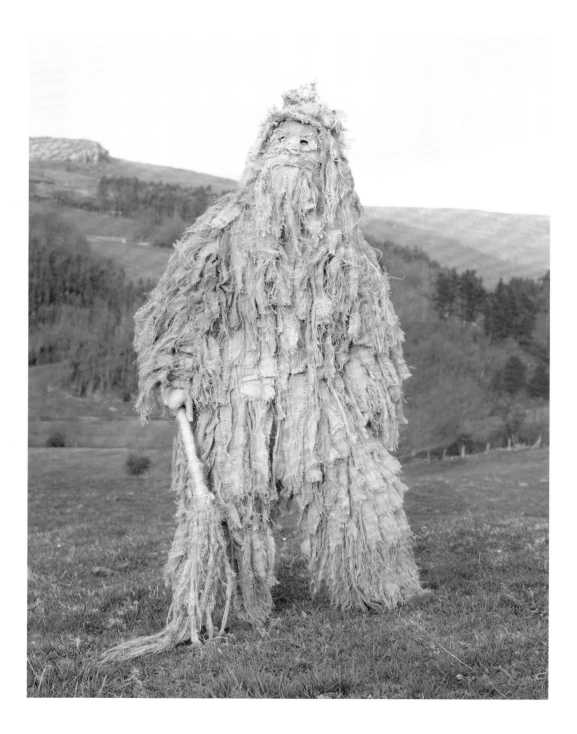

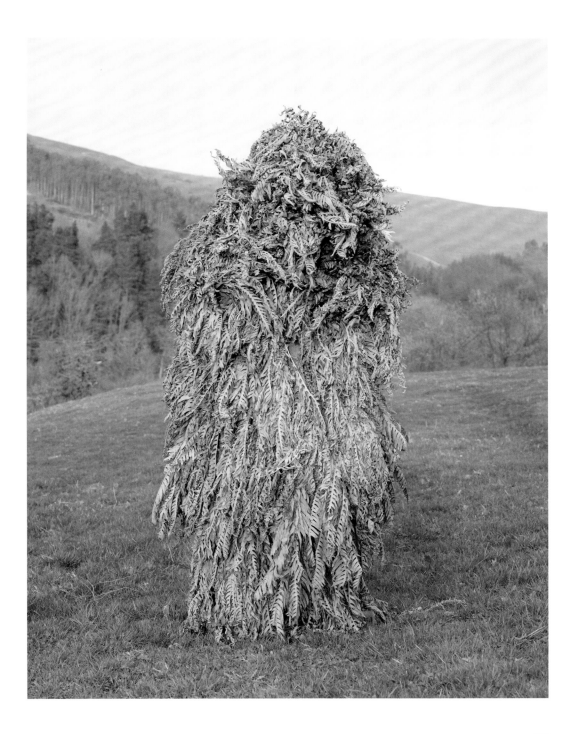

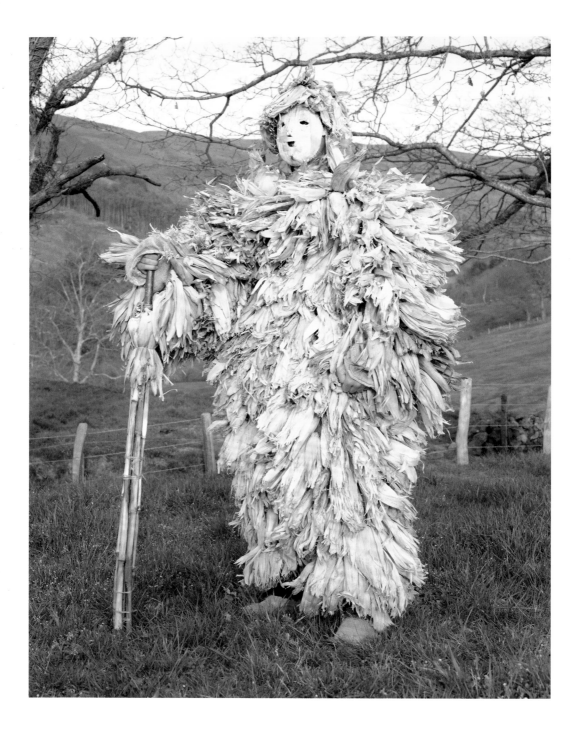

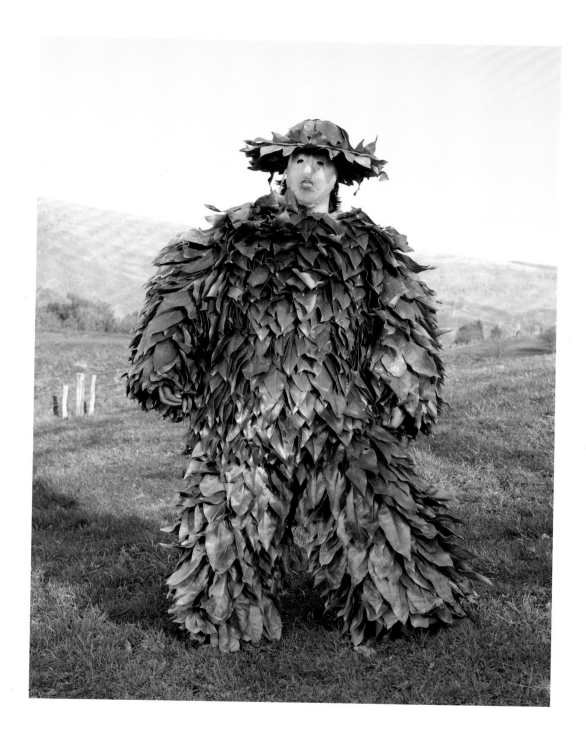

Zarramaco, Silió, Spain

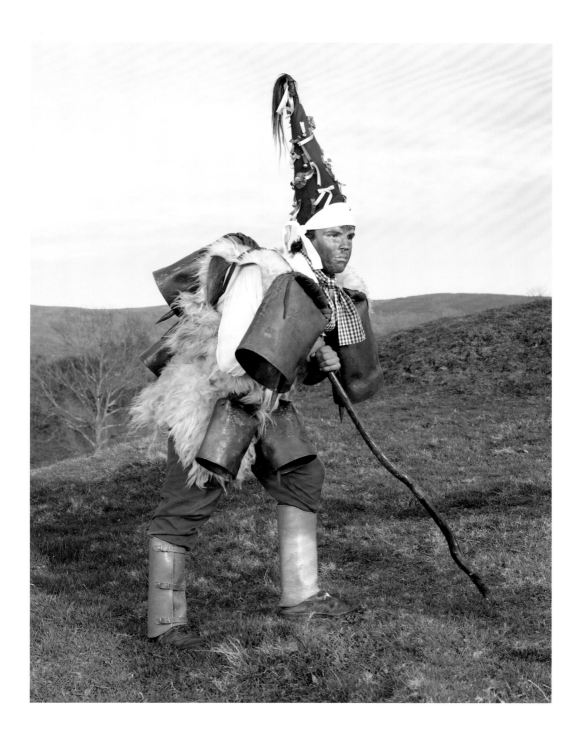

[opposite and following double page] *Caretos*, Lazarim, Portugal

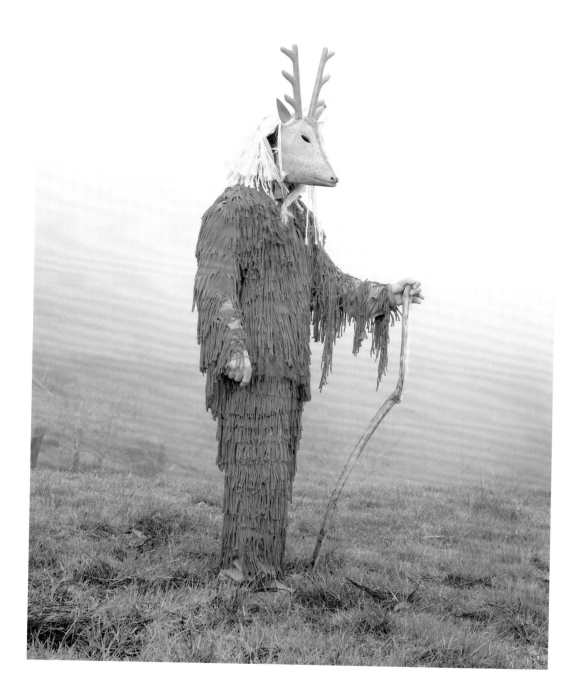

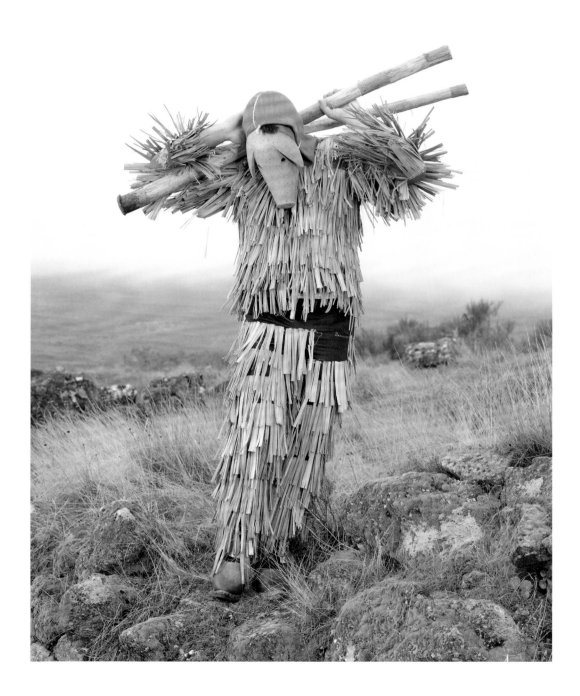

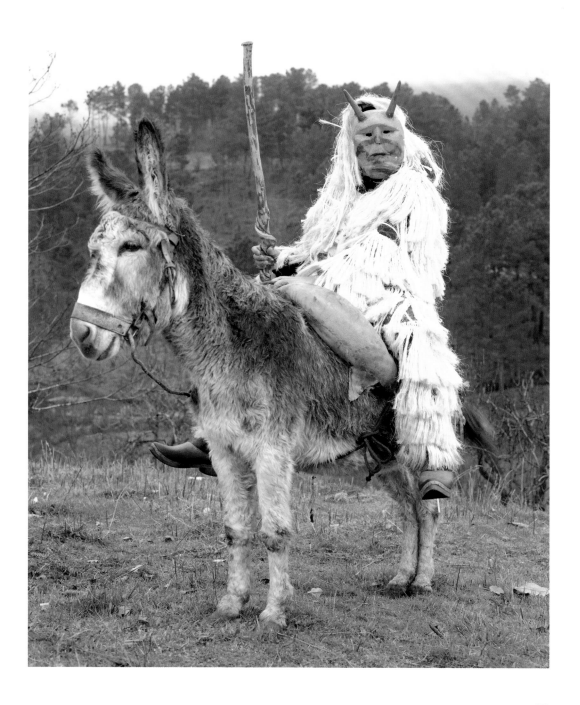

Careto, Lazarim, Portugal

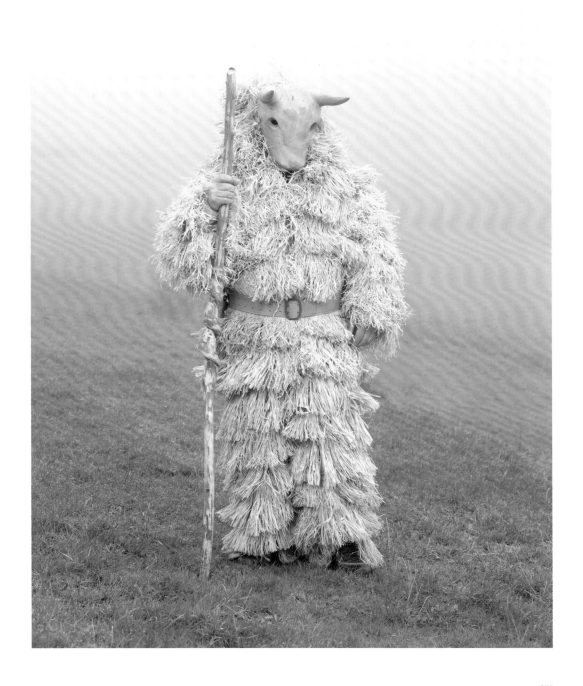

[opposite and following double page] *Caretos*, Vila Boa de Ousilhão, Portugal

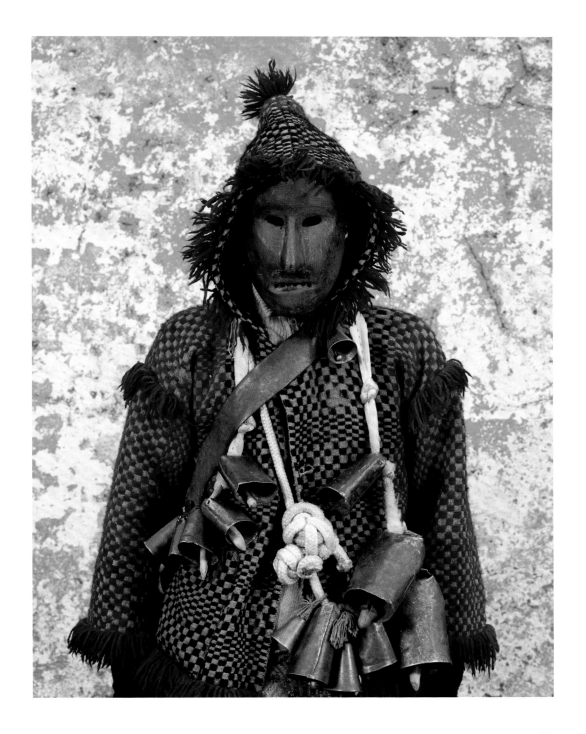

217

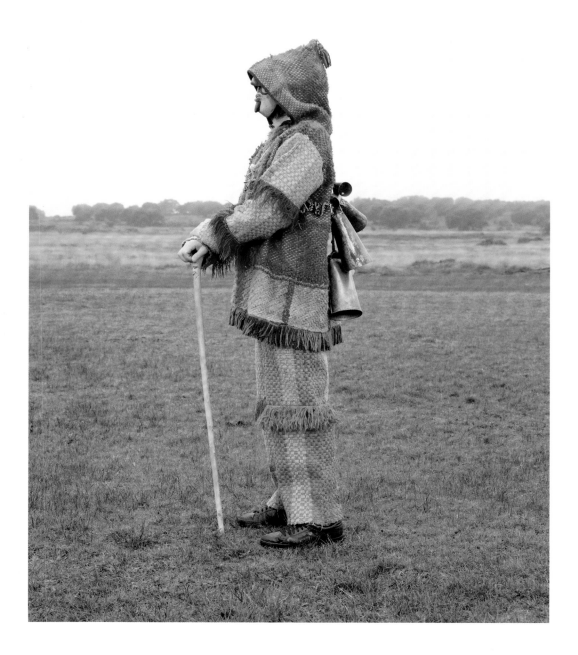

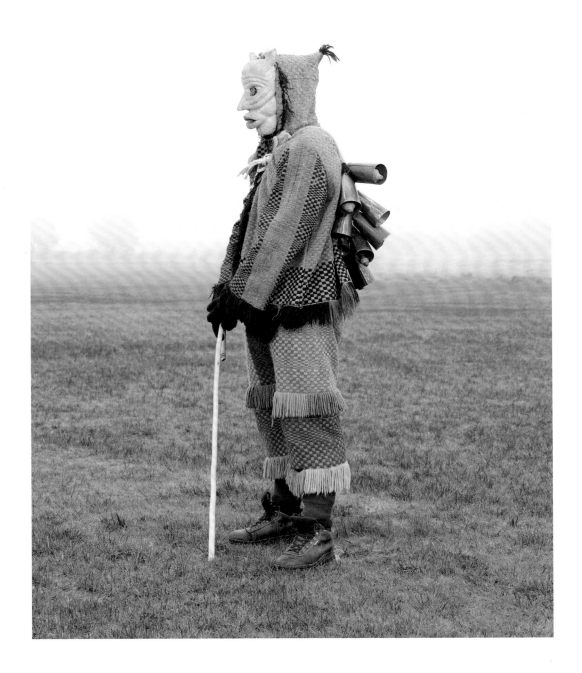

Caretos, Vila Boa de Ousilhão, Portugal

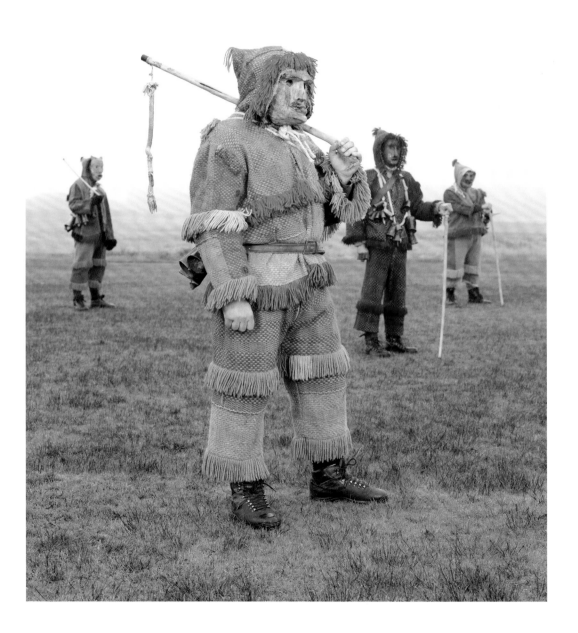

Burryman, Queensferry, Scotland, United Kingdom

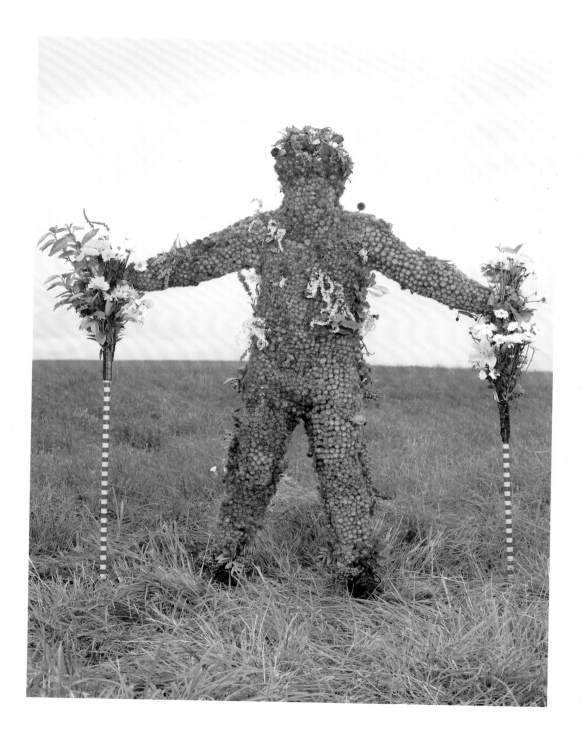

Ours (Bear), Prats-de-Mollo-la-Preste, France

[following double page] *Ours*, Saint-Laurent-de-Cerdans (left) and Arles-sur-Tech (right), France

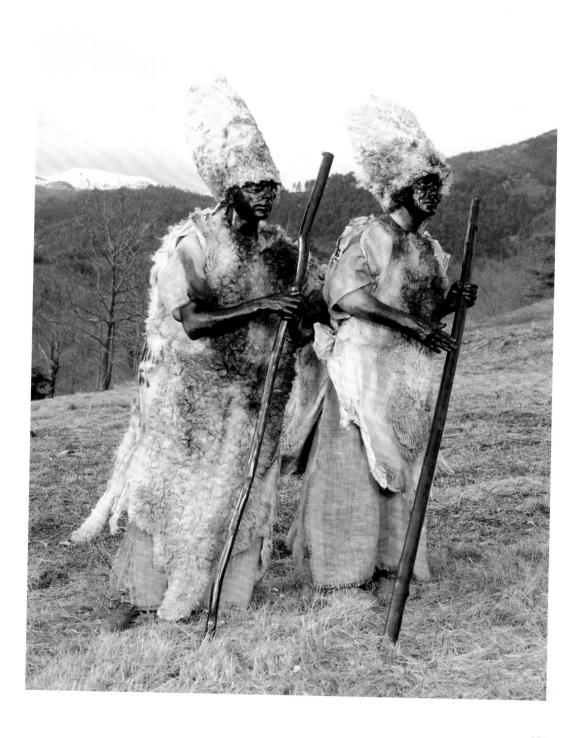

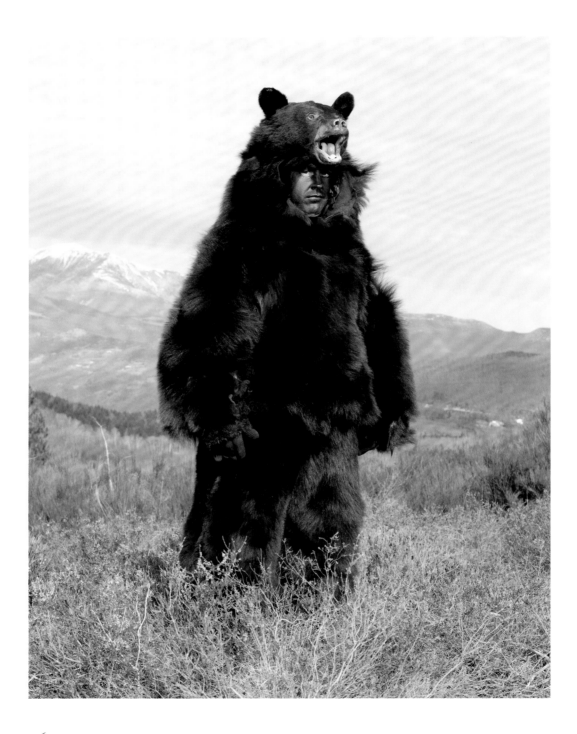

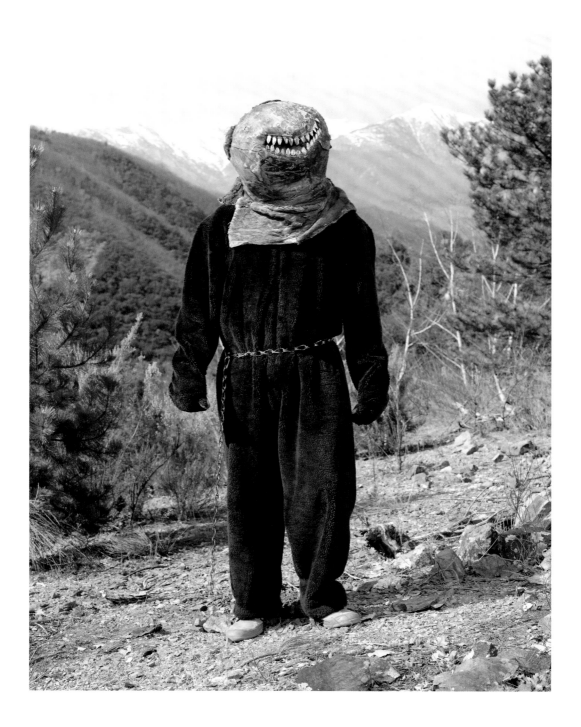

227

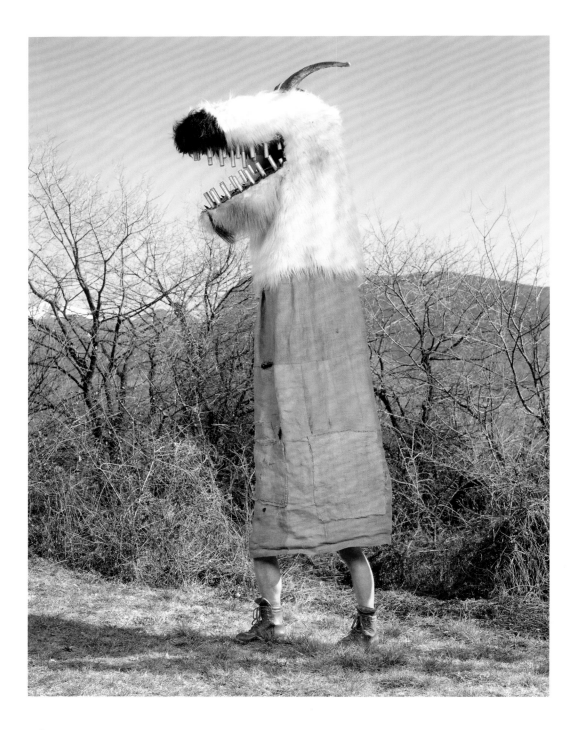

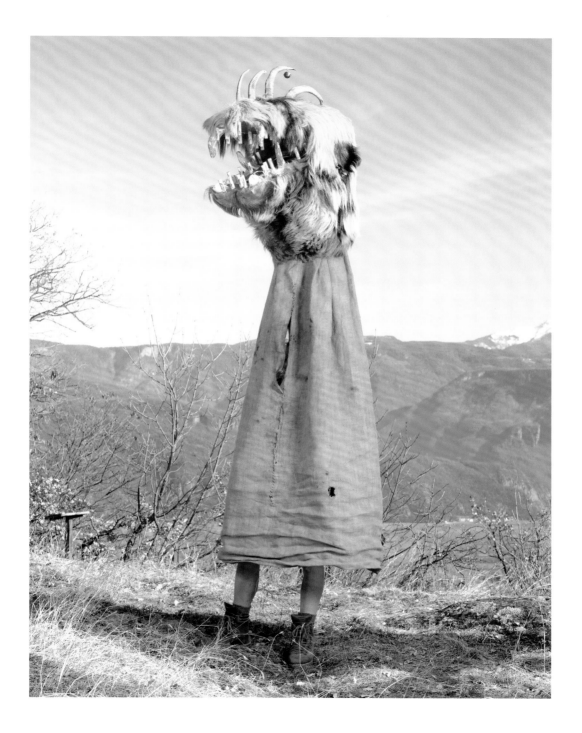

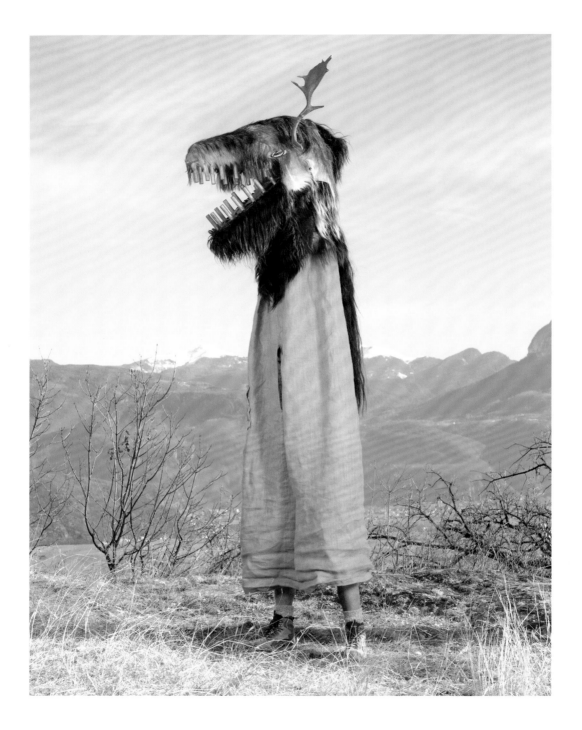

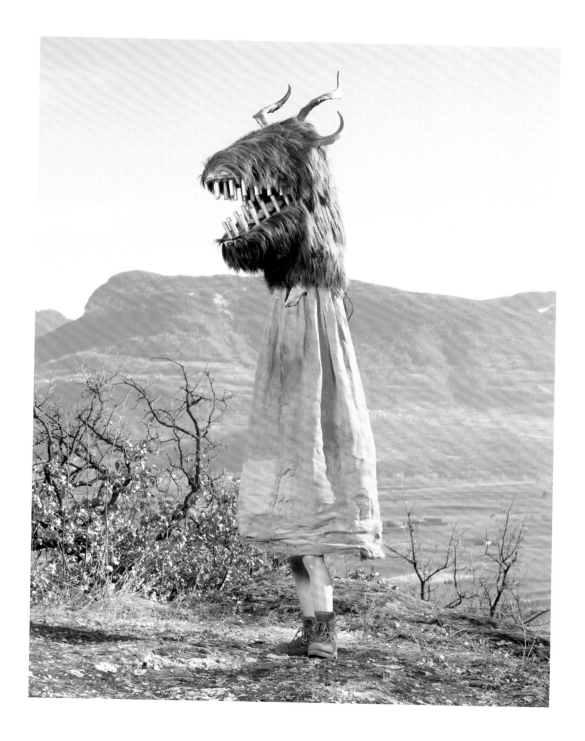

[previous double pages and opposite] *Schnappviecher*, Tramin, Italy

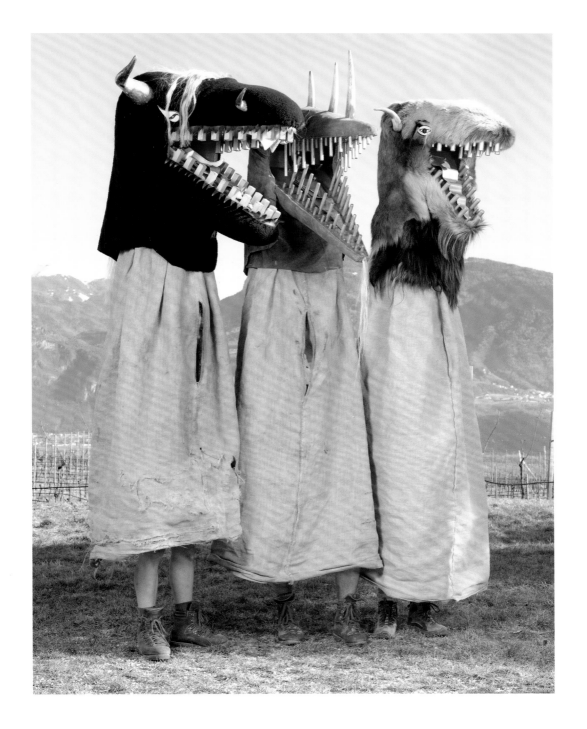

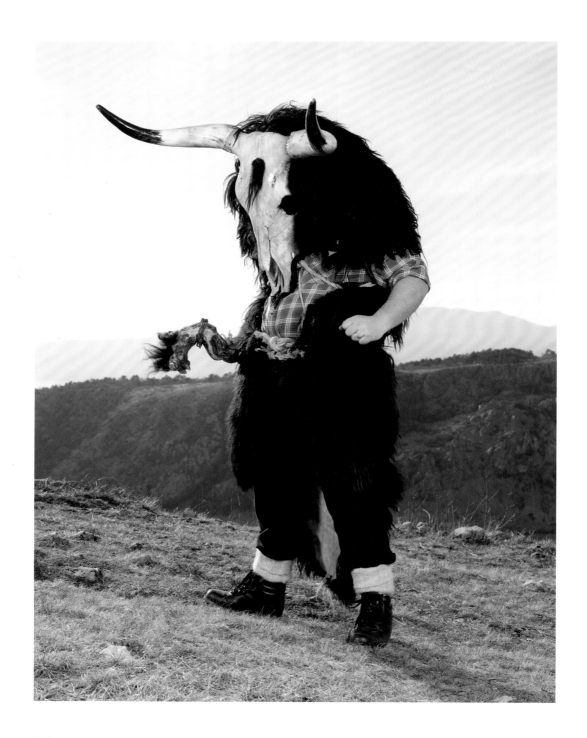

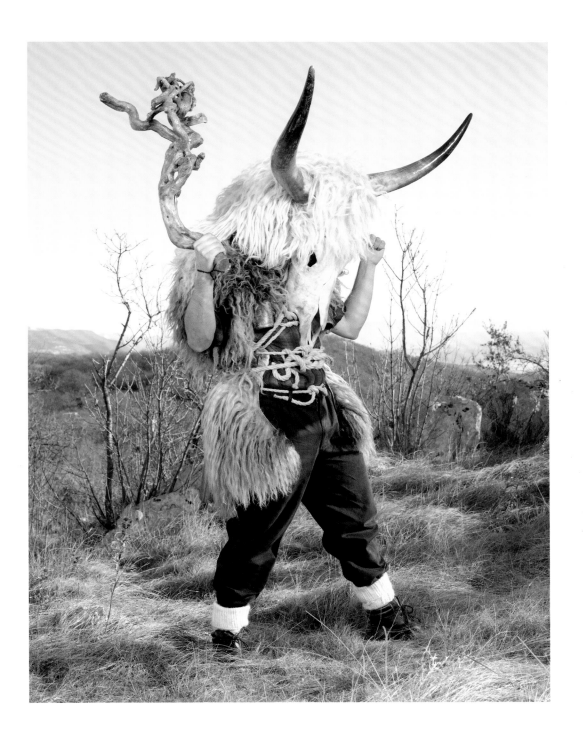

[previous double pages and opposite] *Dondolaši*, Grobnick, Croatia

[following double page and page 240] *Zvončari*, Viškovo, Croatia

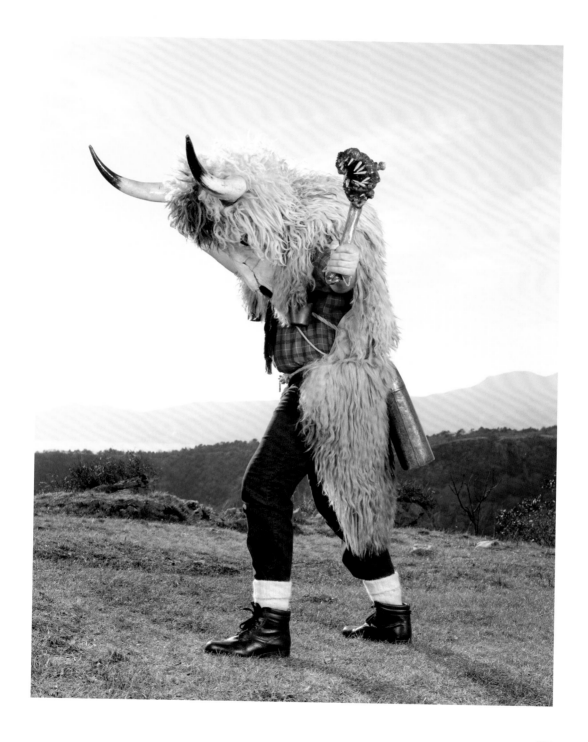

237

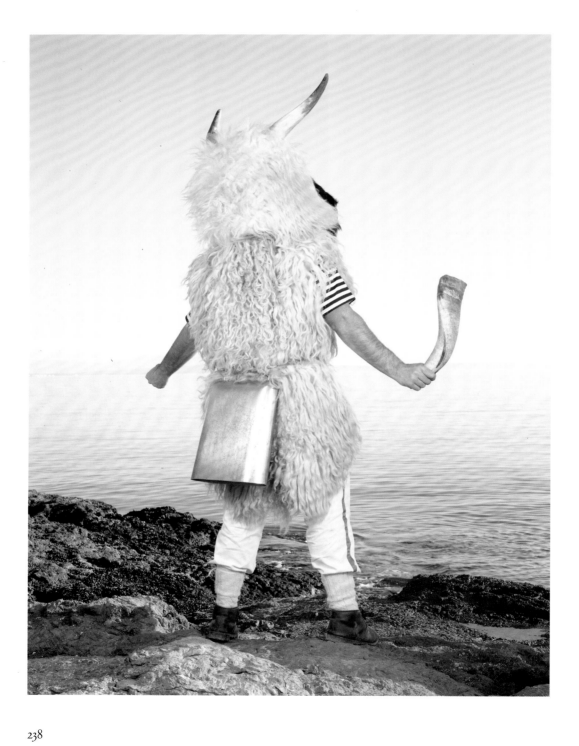

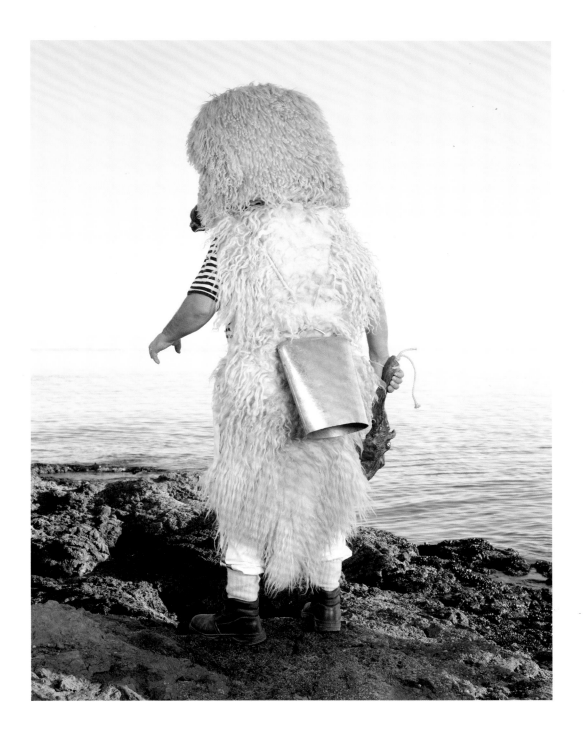

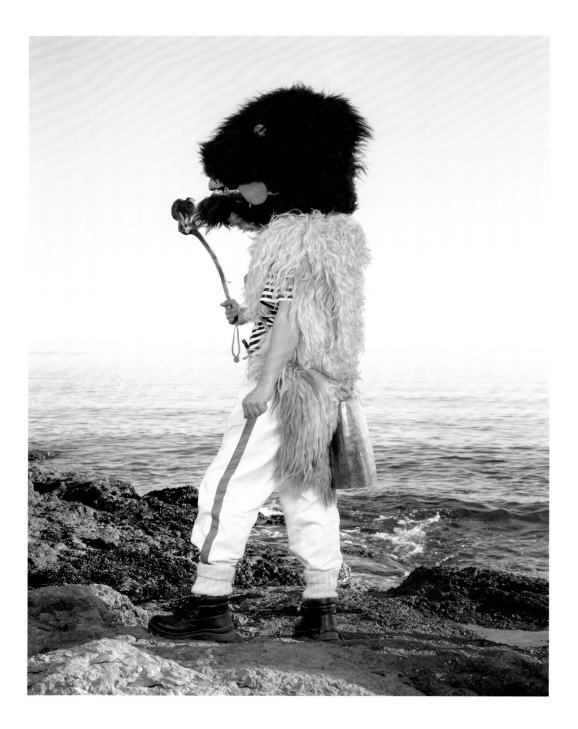

THE WILD MAN AND THE TRADITION
OF MASK IN EUROPE

For as far back as iconographic and literary sources allow us to go, the mask has been used in Europe. Nowadays, what could be described as a festive ritual occurs during the winter across the continent and features characters such as the Wild Man, the Bear, the Goat or the Devil. After an introduction to these different characters or masks, some short explanations of certain masquerades are given, as well as key dates in the calendar.

THE WILD MAN, known in German as *Wilder Mann* and in French as *L'Homme sauvage*, is, according to legend, a son born of the union of a bear and a woman, whether by consent or not. Belonging to two worlds and knowing the intricacies of both, this mythical being is considered a 'superman', destined for the highest ranks of power; many powerful families of the Middle Ages chose one of the legendary hybrid beings as an ancestor.

In most cases, the Wild Man wears a costume made of natural materials or animal skins; his face is rendered unrecognisable, either by a mask or by a costume that covers him entirely, or by black make-up. An accessory – a stick, a club or something similar – and one or more bells complete his outfit. The bells punctuate the steps of the Wild Man, emphasising every move-ment with the sounding of the bell. The weight of these can be as much as 40 kilos, underlining the virility and strength of the character. These bells, as well as the plant and animal matter of the costume, connect the Wild Man to his natural origins; however, through the way he stands and through his dance, he is also a part of the cultural sphere – the coat of skin could equally belong to a shepherd. His costume is therefore ambiguous, as is his role in the tradition of mask. Able to be self-sufficient, he is

sometimes subordinated to other characters, generally humans although often also hybrids. He embodies the complex relationship of love and hate which man maintains with his environment.

THE HUMAN CHARACTERS, that is to say the anthropomorphic characters, that animate the masquerades can be classified into two sub-categories: those who belong to another world, illustrating a 'different' state, with moments of passage and transition, and those who only constitute half of a reality, and therefore must be supplemented by other characters, forming atypical couples.

In the first series are: the Devil, intercessor between the world of the living and the dead and who, paradoxically, generates more laughter than fear; Foreigners who, coming from elsewhere, are considered 'different'; Beggars or Fools, those who do not believe in God; Death or the Dead, ambassadors of the afterlife; the Married, on the border between two 'civil' states; and so on.

The second group includes, for example, the Old Man and the Old Woman, Beauty and the Beast, or again Man and Animal. They represent two sides of the same coin, in a kind of schizophrenic complementarity: Good and Evil, the Here and There, the Civilized and the Wild.

The Woman is an equally popular figure in the tradition of mask, although traditionally played by a man. An unfulfilled fantasy or a homecoming, the carnival provides the perfect excuse for men to assume their femininity or to gently mock their spouses and their mothers, far away from social conventions which still largely condemn female behaviour in a man.

ZOOMORPHIC MASKS (the shaping of something in animal form) are universal. They demonstrate the links that unite man and his environment, in other words culture and nature. Mysterious, fascinating and above all silent, animals were often seen as 'good things through which to think'. They have therefore

been invested with a series of symbols and powers, intended to control man's environment. Every society gives a higher status to whichever animal has the most metaphorical richness, believing it to be the most likely to secure the benevolence of the spirits, the fecundity of land, the fertility of women, and good weather. Amongst the European zoomorphic masks, we can cite the Bear and the Goat. Note that both always appear in the company of a human who tries to somehow keep control, eventually gaining it before losing it again in an endless cycle, as with the seasons or the carnival.

THE CHARACTER OF THE BEAR is widespread in Europe, notably in Austria, the Balkans, Northern Europe or in mountainous regions such as the Alps or the Pyrenees. His costume is made of fur, usually taken from a domestic animal, or of vegetable matter (moss, grass, pea tops, straw, etc.). Accompanied by the character of the Bear Tamer, which appeared in the 19th century following the development of travelling shows, the Bear mimics the behaviour of a tamed animal before it goes wild and rushes towards the crowd. His master must therefore control it and make it submit to his will. Sometimes the savage beast is put to death so as to be able to bring it back to life under the leadership of man – culture prevailing over savage nature. The Bear is a mythical figure of the spring. According to popular tradition, on St. Martin's Day in early November it retires to hibernate for the winter. On the night of the 1st or 2nd February, with the appearance in the night sky of the winter moon that heralds Easter, the mythical bear emerges from its cave to watch the sky. It then decides either to leave its winter lethargy, thereby announcing the imminent arrival of spring, or to plunge back into hibernation for an extra forty days – a new cold snap ahead. Consequently, the Bear appears in a reversal of causality, as 'a maker of spring'. In addition, its ability to spend the winter in a cave in a state of suspension implies that the animal maintains a link with the

afterlife. Finally, it should be remembered that the Bear is closely related to the Wild Man, of whom it could be one of the parents.

THE FIGURE OF THE GOAT is found in many civilisations. Spread throughout the eastern half of Europe, and especially in Romania, the character of the Goat is designated by the terms Capra, Brezaïa or Turca. In Austria, the Habergeiss, equipped with a movable jaw, accompanies Saint Nicolas on his tours. In Poland, this antiquated mask is associated with carol singers. The Goat is sometimes accompanied or replaced by the Billy Goat, especially in the Nordic countries (Julbock, Christmas Goat). The Goat is the central character of scenes that play out a specific sequence in all the regions it is found and where it provides happiness, health and wealth. The 'game of the Goat' inevitably includes jaws that chatter, a guarantee of prosperity for those who hear their noise. The 'plot' promises fertility to the audience, particularly to young girls, and the staging of the death and resurrection of the animal is a symbol of the vitality of nature. Its symbolism also associates life and death. On one hand, the goat is an animal with horns, hooves and wool. These are materials which relate at the same time to the living world – on the animal, they grow, change appearance, deteriorate and die – and the world of death – insensitive to pain, the act of cutting them in no way violates the health of the animal. On the other hand, horns and hooves constitute a physical link between two worlds: through their orientation towards the sky or their capacity to dig into the earth.

Strictly associated with the Goat in the masquerades, the Stag was already present in Greco-Roman mythology and the Celts honored Cernunnos, the horned Gallic god. In the Middle Ages, the Church saw in the disguise of the Stag, as in that of the Goat, the expression of Satan. However, the Stag is equally a symbol of renewal because its antlers bring to mind the tree of life. Today, we meet it again in England in the 'Horn Dance' as well as in Romania and Bulgaria in the Christmas masquerades.

RECURRENT MASQUERADES. Across Europe, it is possible to see the recurrent nature of certain stagings:

— The masquerade of death and resurrection, intended to confirm the regeneration of nature, 'dead' during the winter, through a sort of sympathetic magic which induces imitation;

— The judgement, the killing or the funerals that are supposed to mark an end to the passing year by removing all the negative events that took place during it. Fire frequently intervenes as a purifying agent to put an end to life – of a straw dummy for example. This act also has a social purpose because it condemns the ideal culprit, one whose death symbolically cleanses all members of the community of their responsibilities;

— The ritual of labour, the mask takes care of this symbolic act of fertilisation of the earth, thus ensuring the smooth running and success both of their labour and of the sowing season in the real world;

— Marriage, sex, birth, intended to support and strengthen women's fertility as much as the fertility of the land;

— The control of man over animal, which implies the infallible victory of the first over the second, and signifies the superiority of man over nature and his environment;

— The visit to the home in order to dispense wishes or blessings;

— The gift and search, in the course of which one offers one's goods in the hope that the next year will be favourable in renewing what was lost;

— The plot (primarily involving young girls) during which the masked character passes on a small part of its temporary power, specifically to 'fertilisation'.

Note that at present, although these masquerades are still practised, their ultimate goal is entertainment; the symbolism of the acts is often forgotten and remains, whatever happens, in the realm of illusion.

ELEMENTS OF THE CALENDAR. The mask festivals usually take place on specific dates, usually linked to 'official' and religious calendars, whether Catholic or Orthodox (Carnival, St Anthony, Christmas, etc.). These days correspond, nevertheless, to key moments in a calendar closer to nature and which could be described as 'pagan': festival of light, solstices and equinoxes, the Twelve Days. In addition to this 'natural' calendar, the Roman and Celtic calendars have also left their mark. The origins of this complex historical process result in a combination of different (often contradictory) beliefs previously thought to be irreconcilable.

The masquerades focus mainly on winter and spring. Winter is the period during which the population has most need for the power of the mask. In effect, nature dies, the sun shines more rarely, life is harder. It is essential to act so that winter leaves us and spring, with her vegetation, returns. From a practical point of view, winter is also the period during which the peasants, the principal actors of the masquerades, had more spare time. During the spring, on the other hand, they had to be involved in the replanting of crops.

It should be noted that the traditions of the mask include a cyclical conception of time, unlike the linear model that we usually hold.

Other mask festivals can be arranged at key moments in the life of an individual (birth, baptism, marriage, funerals, etc.). Celebrations that amount to rites of passage: these are moments of danger during which one moves from one status to another, times of transition in which the individual finds themselves temporarily in an in-between place conducive to an incursion by demons.

THE TWELVE DAYS run from December 24 to January 5. They represent the difference between the number of days that make up one year of the Julian calendar and that of the Gregorian

calendar. This period, this 'suspended time', is conducive to the arrival of beings from the beyond. One must therefore channel their energy, protect oneself from them, chase them away and ensure they do not stay in the living world at the end of this critical period. Yvonne de Sike, an anthropologist specialising in ritual and festivals, has described this period perfectly: "These twelve days are not part of the ordinary course of life. [...] The ceremonies which take place between Christmas and Epiphany function to protect men from the real or fictitious dangers facing the world of the imagination, to help the sun in danger of breaking a dangerous curve in its course and to rescue the fertility of grain buried in the earth by a symbolic exhibition of animal sexuality."

DESCRIPTION OF CHARACTERS AND GROUPS

WILDER (WILD MAN) 17, 19, 20

Telfs, Tyrol, Austria
Every five years, a Sunday in January or February

The group of Wild Men form part of the Telfs carnival, called Schleicherlaufen, which has taken place every five years since 1890. In Telfs, all the roles are played by men. The Wild Man costume consists of a hood, jacket and trousers on which is sown lichen, harvested in the summer prior to the carnival [17, 19, 20]. Traditionally each Wild Man, during a dinner before they go out, eats a little lichen from his costume. The mask, carved in wood, leaves the chin free and is adorned with a moustache made from hair from a cow's tail or horsehair. The Wild Men lean on a big stick. Some inhabitants of Telfs see the Wild Men as an incarnation of their ancestors, others see them as the personification of winter demons and darkness.

KRAMPUS AND PERCHTEN 21, 23, 25, 26, 27, 29, 31

Bad Mitterndorf, Styrie, Austria
Werfen, district of St. Johann im Pongau, State of Salzburg, Austria
Schleedorf, district of Salzburg, State of Salzburg, Austria
Saint-Nicholas (December 6) and Epiphany (January 6)

The Krampus have affinities with figures of devils and animals. They fit into the customs of Advent. Either they accompany Saint Nicolas on his journeys or they participate in processions which are exclusively reserved for them. They scare children who have not been well-behaved and pursue and whip the audience in a roar of deafening bells.

For over 100 years the 'Krampusspiel' (Krampus' game) has been organized in Bad Mitterndorf. This is a play, performed in different places, five consecutive times, in which more than 80 actors participate. The characters have hardly changed over decades. The plot depicts, amongst other things, a poor man who confesses to the priest but does not regret his sins and shows no willingness to improve himself. He is therefore killed by the character of Death and then dragged outside his lodgings by two Krampus [29, 31].

As in many other villages in the Salzburg region, the Krampus and Perchten in Schleedorf and Werfen [21–27] are part of a contemporary

evolution of the character, even a reappropriation of the phenomenon, influenced by various trends in alternative music and fantasy films. During the week of Saint Nicolas, hordes of teenagers and young adults participate in various 'games of Saint Nicolas' or 'of Krampus', as well as in terrifying processions. Several thousand Krampus can be found just in the city of Salzburg on certain nights of the festivities. During outings at Epiphany, they are called Perchten. They scare the children and chase away winter with a whip and a loud ringing of bells.

CHRIAPA (GOAT), MEDVED (BEAR) 32, 33

Ružomberok, Liptov region, Slovakia
Shrovetide

In the past, the carnival (Fašiangy) of the Liptov region began on Epiphany. Today, it is confined to Shrovetide. The joyous procession of masked figures, accompanied by musicians and folk dancers, wanders the streets of the village, and harvests eggs, sausage, bacon and doughnuts. The Ružomberok carnival ends with 'the burial of the bass'. Participating in the procession are both anthropomorphic characters – including the Old Man and the Old Woman, the Married Couple, the Barber, the Chimney Sweep and the Gypsies – and zoomorphic figures, such as the Goat [32] and the Bear [33], who, according to tradition, are apotropaic characters (ones who ward off evil spirits), and are synonymous with fertility and abundance.

SMRT (DEATH), LAUFR (JUMPER)
AND CERTI (DEVILS) 35, 37, 38, 39, 40, 41, 43

Třebíč and Nedašov, District of Vysočina, Czech Republic
December 5

In the Czech Republic, Saint Nicolas visits residents on the evening of December 5. He is accompanied by the Angel, some Devils [38–43] and, as everywhere in Wallachia, by Death [35] and the Jumper [37]. The figure of the Devil can be very different from one place to another. In general, he is dressed in dark fur with a long tongue protruding from the mouth of his mask. He sports a tail, a large number of bells and chains and he holds a fork [38]. The Devil scares children because he has a bag designed to 'carry away the naughty people to hell' [39]. The Jumper is a character in a white costume decorated with coloured ribbons and bells. With the help of a leather whip, he clears the way

for the group and announces the coming of Saint Nicolas. Death, an entirely white figure, uses a scythe to 'catch the sinners'.

MACINULA 44, 45
Cisiec region of Zywiec, Poland
New Year

In the region of Zywiec, merry groups of people accompanied by musicians run through the streets of villages at New Year. They are called Wyrwicisy or Dziady. These groups, who put on shows for the villagers and present to them their wishes of happiness for the coming year, consist of characters such as the Jews, the Gypsies, the Chimney Sweeps, the Beggar, the Street Vendors, Death, the Devils, the Bear and the Little Horses. In addition to these are the Macinula [44, 45] who play the role of clown. In their hands they hold a stuffed rabbit or a pig's bladder, which they use to hit the spectators. At times, Macinula lie on the ground so that the Little Horses can jump over them. As with the character of the Goat in other traditions, in Poland the horses are a symbol of fertility and vitality. They play the main ritualistic role, suddenly collapsing to the ground, before other characters, including the Macinula, circle them, and they are finally and miraculously brought back to life.

The figure of the Macinula can be classified in the category of men in rags, who, in turn, are rooted in the tradition of the Wild Man, and are found throughout Europe.

DZIADY SMIGUSTNE (ANCESTORS) 46, 47, 48
Dobra, Malopolska region, Poland
Easter Monday

The group of Dziady Smigustne [46, 47, 48] marches through the streets on Easter Monday. Most are armed with syringes and buckets of water with which they sprinkle passers-by, preferably young girls, or cars that they cross in front of. Generally, water plays an important role in the practices of the Easter cycle. In Poland, Easter Monday soakings are mentioned in documents dating from the Middle Ages, which speak of 'Śmigus Dyngus' (sodden Monday). These sprinklings of water are vested with specific functions: they are supposed to drive away evil spirits, and to ensure the fertility of women and the fertility of the earth, hence the erotic symbolism of the gesture.

STROHBÄR (BEAR OF STRAW) REISIGBÄR (BEAR OF TWIGS), ERBSENBÄR (BEAR OF PEAS), LANGHALMBÄR (BEAR OF LONG TWIGS), STROHMANN (STRAW MAN) 51, 53, 54, 55, 57, 59

Empfingen, Leipferdingen and Ewattingen, Baden-Wurttemberg, Germany
Shrove Saturday and Sunday

In the past, the Straw Man [57] and the Straw Bear were widespread in the German countryside. They were the object of various interpretations: symbols of winter, Wild Men, personifications of lust and even the Devil, heirs of the bear shows of the past.

Most of the traditional Empfingen Carnival characters are inspired by the rural past. In the carnival of yesteryear, the Bear of Empfingen collected for charity in the village and was accompanied by characters dressed in rags. Nowadays, they have abandoned passing the hat in favour of processions in the heart of the village and its outskirts. Each Bear is held on a rope, by a man in a black suit and with a hat for tips. Other characters in the carnival are the Witches with soot that blackens the spectators, the Schantle, the Bäuerle, the Bajasses, the Dominos and the Charroyeur. Bear costumes and Straw Men are made from rye or oat straw [57], pea straw [55] or fir twigs [53, 54].

In Leipferdingen, members of the carnival society meet together in October to make new costumes for the Straw Man [59]. These are made from oat straw cut with a scythe, dried and beaten with a flail; mats are woven and then sewn onto the costume.

In Ewattingen [51], meanwhile, the Straw Bears wear a costume of bands of natural raffia. Composed primarily of adults, this group participates in many Black Forest carnival parades.

PELZMÄRTLE 61

Bad Herrenalb, Baden-Württemberg, Germany
December 24

In the tradition of Straw Men, the Pelzmärtle [61] appears in Bad Herrenalb at Christmas. Accompanied by the Christkindl (Baby Jesus, who here takes the form of a St. Lucy played by a young fairy in white), he reprimands disobedient children and inflicts 'shots' with his stick of birch. The Pelzmärtle costume is made from braided straw assembled and sewn directly onto the wearer.

TSCHÄGGÄTTÄ 63, 64, 65, 67
Lötschental, canton of Valais, Switzerland
February 2 (Candlemas) to Shrove Tuesday
The origin of Tschäggättä is the subject of several theories. Some say it is inspired by bands of brigands who once dressed up in order to steal into the villages, others that they symbolize ancestors back in our world to punish or reward the living, others believe that they are derived from popular theatre. Until the middle of the 20th century, only unmarried men were allowed to wear the Tschäggättä costume. Thus dressed, they scared children and young women, threw them into the snow, blackened them with soot or beat them with bags full of ashes. Today, both children and adults can become Tschäggättä and terrorise the inhabitants of their village.

PELUCHES AND EMPAILLÉS 68, 69
Evolène, canton of Valais, Switzerland
From January 6th to Shrove Tuesday
In Evolène, the carnival opens on the morning of January 6 (Epiphany) with young people waving cowbells. It is also at this time that the first release of the Peluches (The Plush) takes place [68]. Every Saturday until Shrovetide they try to catch people crossing the main street of the village. The Empaillés (The Stuffed) [69], however, only appear on Shrove Sunday; they come out right after Mass and tease the audience with a broom of rice soaked in water from the fountains. On the evening of Shrove Tuesday they burn Poutraze, Evolène's Old Man Winter, while reading his burlesque will. When midnight strikes, the masks are removed, marking the end of the carnival.

URSUL (BEAR) AND URATI (UGLY PEOPLE) 70, 71, 73, 74, 75, 85, 86, 87

Palanca, Bacău region, Romania
Boroaia and Udešti, Suceava region, Romania
New Year

In Romania, masked characters appear mainly between December 24 and January 7. Zoomorphic masquerades played out during this period are mainly those of the Stag (Cerbul), the Goat (Capra), the Bear (Ursul) and the Horses (Calutii). Accompanied by at least one Bear Tamer, the Bears may be surrounded by other characters to form a group of 10 to 15 figures (Gypsies, Old People, Devils, Ugly People, etc.). The Game of the Bear has its origins in the bear tamers, who until the 1940s, roamed the Romanian villages from early spring until mid autumn. According to popular tradition, at that time the animal was invested with various powers. Thus, the Bear Dance, led by its tamer, was supposed to be beneficial to the harvest and to young girls. Bear hair was supposed to protect whoever pulled it out and to have preventive powers. Those who were ill hoped that the beast would drive away sickness and pain. Even today, the animal seems to retain its sacred aura and all its appeal.

Like the Bears of Boroaia [85] and Udešti [86, 87], the Palanca Bears [70, 71] are accompanied by a Bear Tamer (Tigan the Bear Tamer / Ursa) and his wife, followed by the Ugly People [73, 74, 75] wearing masks of fur, to which are attached hair made of sticks, rolls of fabric for the eyes or the mouth, and beans for the teeth.

CAPRA (GOAT) AND CERBUL (STAG) 77, 78–79, 81, 83

Mălini, Mănăstirea Humorului and Corlata, Romania
New Year

The masquerades of the Goat which take place in the towns of Mălini [83] and Mănăstirea Humorului [77, 78–79] are representative of this widespread tradition in Romania. This charade has generally a Goat, and his master, the Old Man (Mos or Mosul), complemented by a variety of characters (Turks, Married People, Horses, Devil, Priest, etc.). Groups of 20 to 30 members are formed. Generally, the Game of the Goat takes place everywhere in the same way: the goat dances, dies and is then resurrected. The Goat consists of a wooden head, decorated with ribbons, with a movable jaw that the wearer can snap open and shut.

The head is attached to a stick, almost horizontal, which is the spine and over which is stretched a cloth decorated with colorful trimmings. This covers the wearer and represents the Goat's body and forces the wearer to move in a bent manner.

The Corlata Stag [81] is surrounded by dancers in traditional dress and armed with a hunting horn. Its masquerade is comparable to that of the Goats: the Stag performs a quick dance, which shows its liveliness. It then dies before being resurrected through the songs and dances of its acolytes.

NUUTTIPUKKI 89, 90–91, 93, 94, 95, 97
Sastamala region of Pirkanmaa, Finland
January 13 (day of Knut)

The tradition of Nuuttipukki (meaning 'Knut goat') goes back to at least the 19th century. The day of Knut (named after King Knut IV of Denmark) was traditionally January 7, but was moved to January 13 (which also ends the Christmas period) during the 18th century. The word 'Nuuttipukki' refers to a full band, formed around the figure of the Goat. Previously, this character was accompanied by other young men, dressed in straw and fur coats, and wearing masks made of birch bark. They went from house to house begging for leftovers from Christmas dinner. Over time, horned masks were abandoned. Masks made of paper or fabric replaced them, before eventually disappearing in favour of commercial masks. The tradition of Nuuttipukki is reminiscent of Joulupukki, a character associated with Father Christmas.

SAUVAGES 99, 100, 101
Le Noirmont, canton of Jura, Switzerland
Last full moon before Shrovetide

To mark the full moon which precedes Shrovetide, the Sauvages (Savages) come out of the forest and cross the pastures before reaching the village, with a soundtrack composed of the ringing of bells, the cracking of whips and the characteristic cry of 'hoy, hoy!'. On their journey, they blacken the faces of everyone they meet, their favourite victims being girls who try to guess who is hiding under the costumes. When they believe they have identified a savage, they shout, 'known!'. Proceedings are then initiated. If the savages catch one of the girls, they blacken her face with polish and then carry her to the fountain where she is thrown into the water.

LUZIFER UND KLEINE TEUFEL (LUCIFER AND HIS DEVILS) HABERGEISS (GOAT), SCHAB 103, 104, 105

Tauplitz, Styrie, Austria
Saint-Nicolas (December 6)

In many places in Austria, Saint-Nicolas is the pretext for processions and masked games; Tauplitz is one of the highlights of this tradition. The masked characters give two performances, one at an inn and the other in the village square. On the evening of December 5, the silence of the winter night is broken by the sound of the bells of Krampus, the cracking of the whips of Schab [105], and impressive characters dressed in straw. It is the latter that announces the arrival of the procession comprising about sixty characters in disguise, including Death (Tod), the Goat (Habergeiss) [103] which tries to pinch members of the audience with its movable jaw or tease them by taking their hats, and Lucifer, who, with his two devils whose horns are supposed to ward off the evil eye and also symbolize strength and power, closes the show. [104]

BUSÓ (DEVILS) 106, 107

Mohács, county of Baranya, Hungary
Shrovetide

The Carnival of Mohács is undoubtedly the best known in Hungary. Busó masks are first mentioned in 1845. According to legend, during the Turkish occupation the people of Mohács put on scary masks with horns and made a great noise. The Turks took them to be demons and fled. Busó masks are monstrous human faces, or heads of devils or animals, mainly cattle. According to tradition, these masks must be painted in part with animal blood. The Busó are armed with huge rattles or cowbells. On the evening of Mardi Gras, a Busó costume is burned in a coffin to symbolise the end of winter.

BOES AND MERDULES, FILONZANA 108, 109, 111
Ottana, province of Nuoro, Sardinia, Italy
Eve of San Antonio, carnival

In Sardinia, especially in Barbagia the central region of the island, there are still many masked rituals – called Carrasegare – featuring zoomorphic (animal) and anthropozoomorphic characters (both man and animal) that have the dual purpose of awakening nature – to promote the fertility of cattle and land, but also of women – and to make the year prosperous and happy. In Sardinia, as everywhere else in the world, carnival is a period of reversal in preparation for the introduction of a new equilibrium. These manifestations of a topsy-turvy world are expressed here specifically through the reversal of the human/animal relationship.

In Ottana, the first masquerades are held on the eve of San Antonio, following afternoon mass. The Boes [109, 111] and the Merdules engage in a permanent struggle: the first attempting to escape from the second, their guards. The Boes run through the village streets, jingling their bells, with one or more Merdules on their heels. Beaten and put to death, the Boes then come back to life and once again a race begins that will end in the same fatal way. As with the cycle of nature – winter gives way to spring and renewed vegetation – the masquerade of death and life is eternal.

The Filonzana [108] is a female character, although embodied by a man. Dressed completely in black, like a widow, she wears an anthropomorphic wooden mask. She holds a spindle and a distaff with which she weaves the thread of life that can be cut at any time with her scissors, particularly when she meets someone unsympathetic or who refuses her a glass. The ease with which she cuts the thread symbolises the precariousness of human existence. When the Boes fall to the ground, she sits down beside them and continues her work.

MAMUTHONES 113
Mamoiada, province of Nuoro, Sardinia, Italy
San Antonio (January 17), carnival

The carnival of San Antonio, which opens the agrarian year, is an opportunity to light large fires. On the eve of the feast of the Saint, after a Mass dedicated to him, his statue is carried in procession and presides over the lighting of the fire on Independence Square. Firebrands are

taken from this fire and are used to light fires in each neighbourhood. The next day, January 17, the masked characters visit each of the fires as 'priests' of renewal. They run around each fire three times and 'bless it' in their own way. The Mamuthones advance in small rhythmic steps, heavy and slow, under the control of Issohadores, who moves in fast, agile steps and wears a traditional costume. The Mamuthones are both animal and man. They wear a black mask of wood from the alder or wild pear tree, made in the past by the wearer himself, and its expression is hard and grotesque.

CERBUS 114, 115
Sinnai, province of Cagliari, Sardinia, Italy
Carnival
In Sinnai, a village in the south of the island, a masked ritual was introduced recently under the name 'Is Cerbus'. Men and children dress up as Stags [115], as Boars [114], as Hunters, armed with firearms, and as Shepherds. A hunt is staged which involves the capture of the 'animals'. This is followed by their killing and by the dancing of the men around the dead bodies.

URTZU AND COLONGANOS 116, 117, 118
Austis, province of Nuoro, Sardinia, Italy
San Antonio Abate (January 17), carnival
In Austis we come across several characters: the Colonganos [116, 117], the Urtzu [118] – dressed in a wild boar skin and with their faces blackened with coal – and Bardianos, guards dressed in black. Two of these keep the Urtzu from trying to escape. The Colonganos of Austis do not wear bells but carry, on their backs, garlands of animal bones, which knock together with a thud, to the rhythm of their jumps. These bones, symbolising death and the wait for resurrection, protect against evil spirits.

MASCHINGANNA, URTZU, BARDIANOS (GUARDS) AND DOMA-DORES (TAMERS) 119, 121, 123, 125
Ulà Tirso, province of Oristano, Sardinia, Italy
San Antonio, carnival
The main protagonists of the Ulà Tirso carnival are the Urtzu [121], the Tamers, the Guards [123] and Maschinganna [125]. They form a procession that travels noisily through the streets of the village knocking

loudly on doors to be invited in. The Urtzu, bound by his Tamers [121], can never enter houses. Several times along the way, he falls under blows from the batons of the Bardianos and the Domadores; other masked characters dance around him to the sound of the organetto (traditional accordion). The beast continues to be reborn until the end of the procession when it finally dies.

SONAGGIAOS AND URTZU 127, 129, 130, 131

Ortueri, province of Nuoro, Sardinia, Italy
Eve of San Antonio (January 17), Eve of St. Sebastian (January 19),
carnival

The Sonaggiaos take their name from the twenty kilos of various sized cowbells and sheep bells that make up their costume [127, 129, 131]. Faces blackened with soot, they wear white sheepskins on their head, and black scarves borrowed from village women. Grouped together, the Sonnaggiaos are the embodiment of a herd of animals. Unlike the Sonnaggiaos, who are always in groups, there is a single bear (Urtzu). Kept on the end of a rope by a guard, the Urtzu throws itself at the spectators, rolls on the ground, climbs trees and the façades of houses [130].

MAMUTZONES 133

Samugheo, province of Nuoro, Sardinia, Italy
Eve of San Antonio, carnival

The Mamutzones of Samugheo are guided by Maistu, the leader, who sets the pace. There are duels between two Mamutzones [133] who pretend to fight. Next to them is the Ommadore, a guard armed with a whip, who keeps the Urtzu on a tether. This is a character with a goat's head, which tries in vain to escape. Exasperated, the Ommadore beats it until it dies. The Mamutzones dance around the corpse then stop to place their headgear (casiddu), on the ground; the Urtzu rises at once and again makes its best efforts to escape.

DJOLOMARI 134, 135, 137, 139, 141
Begnishte, Kavadarci, Macedonia
January 14

The Djolomari [137, 139] come out on January 14, the Orthodox New Year in the old Julian calendar. Their faces blackened, they wear a long beard of fur and shake large bells worn on a belt, using a circular motion of the hips. They pull a donkey that carries food and alcohol, and search from house to house throughout the village. The Djolomari take on quite violent gestures: armed with canes and sticks, they prey on those watching, especially women. Their favorite victims are the characters of Nevesta (the Bride) [135] and Baba (the Old Woman) [134], enacted by men with whom they pretend to copulate. The Djolomari jump over the fires in their path in order to capture the energy of fire and to purify the world. They are also accompanied by a leader, a sort of 'grandfather' in eccentric and phallic costume [141], who acts as moderator when the games become too violent.

MECHKARI 142, 143, 145
Prilep, Pelagonia region, Macedonia
On the eve of Easter Sunday

The costume of the Mechkari (which literally means 'a bear tamer') is a traditional mask worn by the Prilep guild of butchers during the three days of carnival that mark the beginning of Lent according to the Orthodox Christian calendar. It is said that through this custom of wearing costumes made with the skins of goats and sheep slaughtered during the year, the butchers are seeking to redeem their sins of killing and skinning animals. At the beginning of the festivities, after a long search from house to house, the Mechkari, both demons and ancestors, make an oath to dance and to drink until they are in a trance.

BABUGERI AND CHAUSHI 147, 148, 149, 151
Bansko and Razlog, Blagoevgrad region, Bulgaria
January 1, January 13

The masked groups in Bansko are known as Babugeri [147, 148, 149] while in the nearby town of Razlog, they are called Chaushi [151]. The Babugeri hold their masquerade on January 1, in line with the Gregorian calendar, and the Chaushi on January 13. Both groups wear similar goat skin costumes with a tapered hood ('surati') also made of skin. In

the old days, Chaushi and Babugeri wore a red-painted wooden rod as a phallic object suspended in the middle of their bells. In their ritual dance, they brushed against married women to make them fertile, and give them strength and bring them good luck. Nowadays the wooden rod has been removed or replaced by a stick held in the hand.

SOURVAKARI AND BEAR 152, 153, 155, 157, 158, 159, 161, 163, 164, 165, 166, 167
Banishte, Gabrov dol and Leskovets, Pernik region, Bulgaria
January 13

In Bulgaria, in the region of Pernik, the biggest masquerade of Sourvakari is held on January 13, formerly the date of St. Basil's day. The Sourvakari take their name from the word 'Sourva' (New Year) as January 13 corresponds to the Orthodox New Year in the old Julian calendar. According to belief, Sourvakari bring prosperity to the villagers. Austere and bestowed with a certain sacredness, they accompany the 'wedding ceremonies' and perform a dance on the village square, in which they vigorously shake their bells.

In the village of Gabrov dol, the masquerade begins on the night of January 13, late at night around a fire. The next day the Sourvakari tour around homes wishing the residents a good New Year. The masks of the Sourvakari of Gabrov dol [152, 153, 155], also known as 'likove' are characterised by their caps decorated with wings of bird, skins, feathers, stuffed animals, and small mirrors. The costume consists of a blouse and trousers covered with strips of various cloth. Each costume is unique because its creator attempts to make it different.

The Banishte Sourvakari wear a costume of raffia and a mask decorated with horns [158, 159, 161, 163] or a tall mask decorated with skins and bird feathers [164, 165]. The type of mask may vary from one village to another, according to the craftsman who produced it, allowing the style of each to be recognisable. The Sourvakari of Banishte are also accompanied by a Bear [157].

Masked characters in Leskovets [166, 167] wear skins, and give special importance to horns, which are used not only to adorn the top of the head but also to form protruding jaws.

ARAPIDES AND ARKOUDA (BEAR) 169, 171, 172

Monastiraki, Prefecture of Drama, Greece
Twelve Days (January 7)

Two periods are propitious for the appearance of the masked characters: the period from Christmas to Epiphany – the Twelve Days or 'Dodékameros' – popular in the north and the period of carnival. The festival of Arapides, which are typical Macedonian characters, is held on January 7, St. John the Baptist day, right in the middle of the twelve days period. The masked characters, including the Arapides – wear a costume made of skin and a conical mask [169, 171] – and the Bears [172] go through the streets from house to house, leaping in the air, according to tradition, to 'drive out evil spirits with the sound of their bells'. After arriving in the town's central square, all the participants dance together. The Arapides carry a wooden sword, which was added to their costumes during the Turkish occupation of Greece.

KURENTI AND MEDVED (BEAR) 174, 175, 176, 177

Styrie, Ptuj, Slovenia
Shrovetide

According to popular tradition, the Kurent [176, 177], or Korant is a demon which drives away winter and awakens nature. Rooted in rural tradition, the character appears in groups between February 2 and Ash Wednesday, mainly at Shrovetide. It travels through the villages going from house to house to bring happiness and is accompanied by the Devil (Tajfl). The Bear [174, 175] is specific to the Ptuj plain. Accompanied by its Tamer, it goes from house to house where it dances and performs antics.

ŠKOROMATI 178

Podgrad, Inner Carniola, Slovenia
Shrovetide

The Škoromat is one of the most ancient characters in Slovenia. Probably once linked to the cult of the dead, the Škoromati [178] collected presents for 'the meal of boys' on Shrove Sunday. Today, they participate in carnival parades in their village. They are accompanied by other characters, such as Men of leaves and moss, the Bear, the Gypsies, the Farmers and Kliščar – a demonic figure dressed in black with its face blackened with charcoal and soot who catches girls and children with

a large wooden clip. The group thus formed marches to the sound of drums and accordions.

ZARRAMACOS, ALGUACILES, OSO (BEAR) AND ZARRAMACA-DAS [MUSGO MUSGO, PLUMA (EL PAJARO), GALLARONE, CARNERO EN ZANCOS, CENTENO PATA, TRAPO, COLONO, TRAS DE CUERDAS, HUESO] 181–195

Mecerreyes, province of Burgos, Castile and León, Spain
Shrove Sunday

The Carnival of Mecerreyes is one of the most traditional of the Burgos region. On Shrove Sunday the festivities begin with a search, during which the Zarramacos [192], accompanied by the bachelors of the village (Mozos), gather eggs, chorizo, and black pudding as well as money. The cockerel race is the highlight of this carnival. A cock is kept by the Rey (King) on the end of a bough of braided branches. 'Thieves' – bachelors of the village – take it by force and run away, showing it off to everyone, before giving it to the Rey. The Zarramacos [192], the servants of the King, try to stop them and hand out blows with their batons, the tarrañuela. A group of masked characters, the Alguaciles, push the spectators back by throwing ashes at them. The Carnavaladas or Zarramacadas wear costumes made from rags (Trapo [181]), string (Tras de cuerdas [187]), moss (Musgo Musgo [195]), jute (Colono [182]), bone (Hueso [183]), feathers (Pluma [186]), etc.

HARTZA 196

Arizkun, province of Navarre, Basque Country, Spain
Shrove Tuesday

The Arizkun carnival begins on the Thursday before Shrovetide with a children's carnival. On Shrove Tuesday, a wedding procession is stopped by Hartz [196], an animal similar to a bear, which runs through the village stopping at cafés. Hartz criss-crosses through the streets, held firmly by Hartzazain, the Bear Tamer. Sometimes, the animal manages to free itself, and runs in all directions and throws itself into the spectators. His costume, giving the appearance of a big hairy beast is made of eight sheepskins. The same character can be found in other Navarre carnivals, notably Donibane, Ituren, Zubieto and Goizueta, as well as in the remotest villages. In some localities, the Bear doesn't try to escape, but dances to the sound of the tambourine.

ZEZENGORRI 197, 198

Pamplona, province of Navarre, Basque Country, Spain
Second weekend of February

In San Juan – a district of Pamplona – a rural carnival takes place in an urban setting, making it very unusual. Founded in 1977, it was so successful that in 1991, local residents devised their own characters. Based on Basque mythology, they are called Ahari, Basurde, Gaueko, Zaldia (Horse), Zezengorri (Red Bull) [197, 198] and also Lamia. They participate in the carnival along with masked characters from other localities. According to tradition, Zezengorri is the guardian of caves and chasms.

MOMOTXORRO, JUANTRAMPOSO AND MASCARITA 199, 201, 203

Alsasua, province of Navarre, Basque Country, Spain
Shrove Tuesday

The Momotxorro [201] is a half-man, half-bull figure. It is characterised by its violent behaviour with sexual connotations. It attacks all those who block its way and enters houses to 'plunder' them. Its hands and clothes are covered with blood stains. For some, the Momotxorro symbolizes the pagan sacrifice of animals; for others, it is a reminder of ancient clan battles. Made up of a basket adorned with horns, the headgear of the Momotxorro represents a warrior headdress. Legends tell of villagers in the past dressing up as animals to enter homes unrecognised, to burgle them or to attack their inhabitants. On the evening of Shrove Tuesday, hundreds of Momotxorros form an impressive procession which is also joined by Juantramposos [203] and Mascaritas [199], performed by single young men and women.

ZARRAMACOS AND TRAPAJONES 204, 205, 206, 207, 209
Silió, Molledo region, Cantabria, Spain
First Sunday of the year
Each year, Silió hosts the first carnival of the European calendar. Known as 'The Vijanera', it brings together an impressive number of characters typical of European masquerades: the Zarramacos [209] – men dressed in animal skins and wearing bells – The Bear, the Man of rags [204], the Trapajones [205, 206, 207] – people wearing costumes of vegetable matter (corn cobs, straw, moss, ivy, fern, bark, nut shells, chestnut bugs, etc.) – the Horse-skirt, the Old, the Beautiful, etc.. The festival, which begins before dawn, is marked by the release of masked characters followed by the capture and killing of the Bear on the church square. This performance is supposed to illustrate the triumph of good over evil, ensuring the protection of cattle and men, warding off evil spirits and releasing the souls of the dead.

CARETOS 211, 212, 213, 215
Lazarim, Lamego, Portugal
Shrovetide (Entrudo)
When they leave, the Caretos mingle with the crowd and come alive with the sound of rhythm instruments and bagpipes. Their masks, all different, are hand-carved in alder wood each year by local craftsmen. They often have the faces of animals, devils, mustachioed men. The Careto mask is worn with a costume made of various materials: straw [213, 215], animal skins, leaves, strips of wood [212], strips of cloth [211], etc. One of the highlights of the Lazarim carnival is the public reading of the 'will' of Compadre and Comadre (Godfather and Godmother), the Mardi Gras. A solemn procession travels through the village with the effigies of Compadre and Comadre which, at the end, are burned.

CARETOS 217, 218, 219, 221
Vila Boa de Ousilhao, Vinhais, Portugal
Feast of St Stephen (25 and 26 December), Shrove Tuesday
The Caretos (or Mascarados) appear on the feast of St Stephen, and more recently, on Shrove Tuesday. The feast of St Stephen – or 'Festival of Boys' – is part of the twelve days cycle that begins on December 24. There are about thirty masked characters, the main ones being the King (Rei or Mordomo), his subjects or vassals (Vassais), the four

young people (Moços) and the Caretos. On December 25, the masked characters are welcomed at the homes of the villagers. In each house, they dance and sing then beg for chestnuts, sweets, chorizo and money. The next day, the Moços and the Caretos appear first at the home of the Rei and then head to church where a Mass is held in honour of St. Stephen. Yet, the Caretos have no right to enter the church and must wait quietly outside. After Mass, the Rei offers bread and wine to all. In the afternoon, the women prepare the 'Table of St Stephen', also known as the 'Table of the People'. On boards covered with white tablecloths, they place 'offerings' – grain, fruit, bread and wine. The Caretos move around the table and make mischief until the priest blesses the bread and wine. The Caretos can be armed with a stick or a broom with which they pretend to hit spectators, a gesture that symbolises purification and the fight against evil spirits.

BURRYMAN 223
Queensferry, Scotland, United Kingdom
Second Friday in August, during the Ferry Fair
The Burryman appears at the Ferry Fair in Queensferry on the second Friday in August. It is first mentioned in 1687, but many say the Burryman is even older. It takes its name from the Burdock plant (Burr), which is used to make its costume. According to tradition, this character would frighten away evil spirits and would be a symbol of the regeneration of nature and fertility for crops. The Burryman holds two sticks decorated with flowers on which he rests his arms. He is also supported by two assistants who are not disguised, and who guide him. The Burryman's movements are extremely limited by the costume, though this does not stop him spending the whole day walking around the town. The Burryman must remain silent. He is also accompanied by a group of children going from house to house collecting money. His obligatory stops are the town hall, several shops and the pubs. If you give him whisky and money it is supposed to bring good luck.

OURS (BEAR) 225, 226, 227

Prats-de-Mollo-la-Preste [225], Saint-Laurent-de-Cerdans [226] and Arles-sur-Tech [227]
Pyrenees-Orientales, France
Three successive Sundays in February

Taking place in these three small Languedoc towns, this ritual is inspired by the legend that at the end of their hibernation, bears sought out girls and made attempts on their virtue. It results in a dramatic performance with several variants. Usually escorted by the Hunters, and the sound of gunfire, the Bear goes down to the town where he tries to catch the girls (or, in Arles-sur-Tech, the character of a woman played by a man) to lead them in a dance-duel (which ends in Prats-de-Mollo, with the blackening of the audience). Hunters kill the Bear with a gun. The body of the animal is placed on a chair, and then comes back to life. It is shaved, in a ritualistic but very comic and theatrical way. Once cleaned up, the animal has become a man.

SCHNAPPVIECHER (OR WUDELEN) 228, 229, 230, 231, 233

Tramin, South Tyrol, Italy
Carnival, Shrove Tuesday (odd years – during the procession of Egetmann)

From January 7, the Schnappviecher [228–233] of Tramin spread terror in the streets of this wine village, and participate in the procession of the Egetmann, held every other year on Shrove Tuesday. Butchers and the Drivers who accompany them struggle to contain these horned characters and to protect the public from them. When the procession passes a fountain – or the site of an old fountain – a Schnappviech is slaughtered by a Butcher. Some interpret this gesture as the killing of winter. A large plough is also part of the procession – 'Eget' also means 'harrow'. The public are constantly smeared with soot or make-up, and sprinkled with hay, sawdust or confetti.

The Schnappviecher – horned creatures without ears but with metal tongues – can be an impressive size, up to three metres high. Their lower jaw is movable and is activated by means of a rope, while its wooden teeth produce a loud cracking noise. The origin of these characters is unknown. Their appearance could link them to the dragons of religious imagination or of medieval epics and myths.

DONDOLAŠI AND ZVONČARI (BELL RINGERS) 234, 235, 237, 238, 239, 240

Grobnick and Viškovo, county of Primorje-Gorski Kotar, Croatia
January 17 at Shrovetide

The Dondolaši of Grobnick [234, 235, 237] are similar to the 'bell ringers' known as Zvončari in northwestern Croatia. The name Dondolaši is a reference to shepherds once hired by rich landowners to protect their herds from wild beasts, and who made the predators flee by using noisy objects such as bells. They wear clothes made of sheepskin, with the skull of a bull on their head and their faces blackened with soot. Even if the tradition of these shepherds has disappeared, they are remembered through the carnival. The Zvončari of Viškovo [238, 239, 240] have one large bell on their lower back. Their heads are covered with a huge zoomorphic mask with horns, and they often have a long red tongue. When they walk, the Zvončari sound their bells, sometimes bumping against each other. They can also be grouped into a circle, bells facing inwards, the purpose being to produce a real cacophony with the bells.

ACKNOWLEDGEMENTS

GERMANY Werner Baiker (Strohbären Empfingen Fastnacht), Matthias Burchardt, Götz Diergarten, Nadja Dörfel, Peter Granser, Ulrike Krause (Strohbären Ewattingen), Reinhold Nofer, Heinz Paps (Phase One), Hartmut Peschel (town of Leipferdingen) **AUSTRIA** Roman Gruber (Tauplitzer-Nikolospiel Gruppe), Nina Neuper, Claudia et Hubert Neuper, Nathalie and Andrew Phelps, Bernhard Salferllner, Gisèle Vienne, Franz Winkler, Oliver Wurglits **BULGARIA** Vladislav Georgiev Chilev (Chaushi of Gaprebara, Razlog), Desislava Georgieva Bahanova (Babugeri of Bansko), Svetla Rakshieva and Iglika Mishkova (Sofia National Ethnographic Museum), Malin Stoilov Budinov (Survakari of Leskovec), Veselin Vasilev Vladov (Survakari of Banishte), Kiril Velinov Stoev (Survakari of Gabrovdol) **CROATIA** Marijana Kalčić Grlaš, Stefan Ozren (Halubjski zvončari), Nikola Vrancic (Kolja, Udruga Grobnički dondolaši) **SCOTLAND** Helen Frik, Seba Kurtis, John Nicol (Burryman) **SPAIN** Ahari Kultur Taldea, Benito Mambrillas Portal, César Rodriguez Fernandez (La Vijanera à Silió), J. Salvador Alonso de Martin (Masks of Mecerreyes), Enrike Zelaia (Altsasuko ihauteriak, Alsasua) **FINLAND** Risto Hakomaki (National Museum of Finland), Pauli Kylväjä, Janne Lehtinen, Karoliina Nikitin, Maria Pietil. (Sastamalan seudun Museo), Juhani Ruohonen (Satakunnan Museo), Karoliina Salmelainen (Glims Farmstead Museum, Espoo) **FRANCE** Jeanne Maison (Mayor's Office of Prats-de-Mollola-Preste), Monsieur Pareir (Mayor's Office of Saint-Laurent-de-Cerdans), Sébastien Raya (Mayor's Office of Arles-sur-Tech) **GREECE** Petros Efstathiadis, Alatzas Stefanos (Arapides, Drama) **HUNGARY** Vidàk Csaba, Gergely Laszlo, Diana Szentgyorgyi **ITALY / SARDINIA** Associazione culturale 'Boes et Merdules'de Ottana, Associazone culturale 'Sos Colonganos', Associazone culturale 'Sos Merdules Bezzos de Otzana', Associazione culturale S'Urtzu e sos Bardianos di Ulà Tirso, Marco Cadinu (Associazione culturale Atzeni – Beccoi Mamuthones, Issohadores e gruppo di ballo, Mamoiada), Francesco Cinus and Roberta Lecca (Is Cerbus di Sinnai), Giulia Marchi, Tonino Musu (Associazione culturale Mamutzones de Samugheo), Andrea Onazi (Associazione culturale Sonaggiaos e s'urzu di Ortueri), Mario Paffi (Museo delle Maschere Mediterranee), Bruno Vicari **ITALY / SOUTH TYROL** Giovanni Kezich (Museo degli Usi e Costumi della Gente Trentina), Stefan Steinegger (Traminer Schnappviecher) **MACEDONIA** Edith Joseph, Ivica Manasievski, Alex Odjakli, Filip Trajkoski (Mechkari de Prilep), Lazarov Vangel (Djolorami de Begniste) **POLAND** Piotr Biaton and the Dziady Smigustne of Dobra, Katarzyna Majak, Pavel Sleziak and the Wirwicisy de Cisiec **PORTUGAL** Casa do povo Lazarim (Caretos de Lazarim), Patricia Almeida, Toze Vale (Caretos de Vila Boa Ousilhão) **CZECH REPUBLIC** Martin Fila, Václav Jirásek, Martin Jmik and the Certi de Třebíč, Martin Kollar, Petr & Frantisek Sery and the Certi de Obec-Nedašov, Aleksandra Vajd **ROMANIA** Elena Candrea (Grupul folcloric Voinicelul, Mănăstirea Humorului), Tiganescu Culita (Assamblul folcloric 'Capra din Mălini'), Iacob Dumitru (Assamblul folcloric 'Ursü din Udeşti'), Hogeh Florim (Formatia artistica Cerbul din Corlata), Gheorge Galeş (Caminul cultural Boroaia), Simona Ghiorghies (Astra de Sibiu Museum), Liliane and Florim Hormulese (Assamblul folkloric 'la portile neamului', Palanca) **SLOVAKIA** Alice Hura an Charles Bugan, Igor Liptov (Folklórny súbor Liptov, Ružomberok) **SLOVENIA** Danilo Fabjancic (Hrušiški škoromati, Podgrad), Natasa Kosmerl, Krizaj Zvonsko (Kurenti de Ptuj) **SWITZERLAND** Mathieu Bernard-Reymond, Frédéric Chevrier and the Empaillés d'Evolène, Yann Gross, Yann Laville et Grégoire Mayor (Musée d'ethnographie de Neuchâtel), David Mauris (Comité d'animation d'Evolène), Loan Nguyen, Nicole Ritler (Office de Tourisme) and the Tschäggäta de Lötschental, Olivier Roillat and les Sauvages de Noirmont.

Many thanks also to the following people:
Jean-Pierre Blanc (Villa Noailles), Hélène Borraz (Thames & Hudson, Paris), Erik Bos and Sander Kreman (Galerie Nouvelles Images, The Hague), Emilie Botteldoorn (Musée International du Carnaval et du Masque, Binche), Ariane Braun (Kehrer), Matthias Burchardt, Cadre en Seine, Victor Cortina (Ego Galleria), Paul Cottin (Fondation d'entreprise Hermès), Christel Deliège (Musée International du Carnaval et du Masque, Binche), Anne Douzals, Daniel Favier, Léo Favier, Geneviève Gauckler, Gesa Hansen, Petra Helck, Katsuya Ishida (MEM, Tokyo), Cory Jacobs (Fondation d'entreprise Hermès), Klaus Kehrer, Annette and Rudolf Kicken (Kicken, Berlin), Maïnig Le Bacquer (Musée des Confluences, Lyons), Dewi Lewis, Madé, Michael Mauracher (Fotohof, Salzburg), Sabine Mäuseler (Musée International du Carnaval et du Masque, Binche), Reinhard Mlineritsch (Fotohof, Salzburg), Anne Morin, Didier Mouchel, Thomas Neurath (Thames & Hudson, London), Francesca Peliti, Pascal Pillu, Jean-Claude and Françoise Quemin, Patrick Rémy, Manon Renonciat-Laurent (Fondation d'entreprise Hermès), Sophie Robnard (Institut Français), Jean-Marie and Catherine Schneller, Wouter Schuddebeurs, Herman Seidl (Fotohof, Salzburg), Aurélie Sement (Ville de Petit-Quevilly), Moritz Stipsicz (Momentum Gallery, Vienna), Didier Thévenin, Stéphane Wargnier, Robert McLiam Wilson.

Caroline, Théophile and Antoine Fréger.

Published in the UK in 2012 by

Dewi Lewis Publishing
8 Broomfield Road
Heaton Moor
Stockport SK4 4ND
England

www.dewilewispublishing.com

Third reprint May 2014

Design: Léo Favier

Translation: Emma Lewis

Image Processing: Kehrer Design Heidelberg (Patrick Horn, Jürgen Hofmann)

Production: Kehrer Design Heidelberg

ISBN: 978-1-907893-23-0

Printed in Germany